WOMEN AND THE UNITED NATIONS

REFLECTIONS AND NEW HORIZONS

List of Contributors

Camillo Antonio
Enid Burke
Eugenia Date-Bah
Konrad Fialkowski
Anne Forrester
Leena M. Kirjavainen
Tamara Martinez
Chafika Meslem
Adot Oleche
Sylvia Perry
Kaisa Savolainen
Filomina Chioma Steady
Archalus Tcheknavorian-Asenbauer
Remie Touré
Reginald van Raalte
Rosina Wiltshire

Forum of Women Professionals

WOMEN
UN *and the* ITED
NATIONS

edited by
Filomina Chioma Steady
and
Remie Touré

SCHENKMAN BOOKS, INC.
ROCHESTER, VERMONT

Copyright © 1995

Schenkman Books, Inc.
118 Main Street
Rochester, Vermont 05767

Library of Congress Cataloguing in Publication Data

Women and the United Nations: reflections and new horizons /
edited by Filomina Chioma Steady and Remie Touré.
 p. cm.
Includes bibliographical references.
ISBN 0–87047–103–1 (cloth) ISBN 0–87047–104–X (pbk.)
 1. Women in development. 2. Sustainable development. 3.
United Nations—Economic Assistance. 4. United Nations—Technical
assistance. I. Steady, Filomina Chioma. II. Touré, Remie.

HQ1240.W6557 1995 305.4—dc20 95-34431
 CIP

Text Design by Debra A. Glogover

Printed in the United States of America

CONTENTS

PART IV: RECOMMENDATIONS

Boutros Boutros-Ghali, Secretary-General, United Nations.

FOREWORD

At the United Nations, the promotion and protection of women's rights are central objectives. Since 1946, the Commission on Human Rights and the Commission on the Status of Women have actively promoted women's rights. One hundred and thirty-nine countries—more than three-quarters of the organization's current membership—have now subscribed to the Convention on the Elimination of All Forms of Discrimination against Women. In December 1993, at its forty-eighth session, the General Assembly adopted the Declaration on the Elimination of Violence against Women. Now is the time for member states to consider putting that document in legally binding form.

Some of the most significant achievements for women have been made by women working through the United Nations. Using the United Nations as a forum, women from around the world have joined together to raise awareness of women's rights. In the cycle of World Conferences on Women, starting in Mexico City in 1975 and culminating in the Fourth World Conference in Beijing in 1995, women are working, through the United Nations, to set internationally agreed strategies, standards, and goals. They are using the United Nations, with its many agencies, programs, and funds, as a mechanism for putting words into action.

Women's issues are of concern not only to their own communities but to all women everywhere. The United Nations is a forum of choice for the discussion of problems and their solutions. Discussing global issues, while retaining respect for historical and social specificity, is emerging as a hallmark of the continuum of United Nations global conferences.

With this in mind, we look forward to the Fourth World Conference on Women, to be held in Beijing in September. Twenty years

after the First World Conference on Women set out the three themes of equality, peace, and development, the Beijing conference offers an opportunity to assess the continuing obstacles to women's advancement. Building upon the series of landmark conferences and summits held in the first half of this decade—on children's rights, the environment, human rights, natural disasters, population, and social development—Beijing offers us an opportunity to achieve a concrete program of action for progress into the next century.

In the global effort for peace and enduring progress, the promotion and protection of women's rights are central. Success in these tasks means progress for everyone: young and old; men, women, and children. There is no better way to open the second half-century of the United Nations than by ensuring equality, peace, and development for women by the opening of the twenty-first century.

—Boutros Boutros-Ghali
Secretary-General of the United Nations

PREFACE

The objectives of the United Nations Charter remain as valid today as they were in 1945. They remind us that the achievement of development, peace, and human rights is a continuous and unrelenting struggle. Women have always been central to this progress and have often borne more than their share of the sufferings. It is only since 1975, however, with the First World Conference on Women, that women have been increasingly recognized, not only as beneficiaries of development and technical assistance efforts, but also as full actors and key partners in the development process. In that 1975 conference, efforts were made, for the first time to link women's issues to development. This gave rise to what has become known as the "Women in Development" approach, which firmly places women on the development agenda. All agencies of the United Nations system have since adopted this concept, which usually combines the mainstreaming of women's issues into programs, projects, and research activities, together with activities specifically targeting women.

The United Nations system has an obvious and special role to play in which all of us, women and men, must take our parts. The United Nations is an extraordinary force in mobilizing minds and means for a cause; through its advocacy role and its mandate, the United Nations must be the prime mover of ideas and universal values. In UNIDO we believe that without economic growth and sustainable industrial development, no social progress can be achieved in a sustained manner. Employment opportunities must be created for all. Human resource development is a key to offer women and men more options for their development and that of their communities

and societies in general. Technological advances and progress also carry responses and solutions to alleviate poverty and drudgery and to improve the quality of life for all.

We in UNIDO, as members of the United Nations family of organizations, accept the responsibility that has been bestowed upon us. It is our common concern, and it is a commitment that we all very much feel and share. The forthcoming Fourth World Conference on Women in Bejing should be viewed as a conference of real commitments, both political and financial, to bring about equality in all spheres of life.

— Mauricio de Maria y Campos
Director-General, UNIDO

ACKNOWLEDGMENTS

The Forum of Women Professionals would like to thank the Secretary-General of the United Nations, Dr. Boutros Boutros-Ghali, for his support, and wish to acknowledge the members of permanent missions in Vienna who made presentations at the seminar. Thanks and gratitude also go to Ms. Gillian Sorenson, Under-Secretary for the fiftieth anniversary of the United Nations, for financial support toward publication and follow-up activities. Special thanks to Mr. Mauricio de Maria y Campos, the Director-General of UNIDO for his statement and his financial support. Ms. Chafika Meslem for presenting the keynote address, and Ms. Anne Forrester, Deputy Assistant Administrator, UNIDO, for presenting a theme paper. Sincere gratitude is extended to Mr. James Gustave Speth, Administrator, UNDP; Mr. Abdoul Diouff, Director-General, FAO; Ms. Elizabeth Dodeswell, Executive Director, UNEP; Mr. Michel Hansenne, Director-General, ILO; Mr. Frederico Mayor, Director-General, UNESCO; and Dr. Hans Blitz, Executive Director, IAEA. The Forum also wishes to thank Mrs. Archalus Tcheknavorian-Asenbauer, Managing Director, Industrial Sector and the Environment Division, UNIDO, and founder of the Forum of Women Professionals, and Mrs. Olubanké King-Akérélé, Managing Director, Country Strategy and Programme Development, UNIDO. Thanks are also due to Ms. Marie-Anne Martin, chief of the unit on the integration of women in industrial development, UNIDO and Ms. Sotiria Antonopoulou, chief of the Personnel Administration and Social Security Section, UNIDO. A number of women have worked in the background to make the seminar possible and also deserve our thanks. These include Ms. Agneta Zednicek, secretary of the Forum of Women

Professionals, Ms. Emily Hamel, Ms. Sarah Mutua, Ms. Sabina Stroh and Ms. Mandisa Memani. We also wish to thank our male colleagues from UNIDO, especially Mr. Peter Pembleton, the Atomic Energy and other Vienna-based UN organizations and the permanent mission in Vienna for their support and participation at the seminar.

The Forum of Women Professionals wish to thank all United Nations organizations, the media, and individuals who provided photographs for this book.

*I*NTRODUCTION

Filomina Chioma Steady,
Remie Touré,
Enid Burke,
Adot Oleche

WOMEN AND THE FIFTIETH ANNIVERSARY
OF THE UNITED NATIONS

The advancement of women and the elimination by the year 2000 of gender-based discrimination, both de jure and de facto, are important agenda items for the United Nations. They reflect the culmination of commitments by the international community that span a period of some fifty years. The UN Decade for Women (1976–85), which promoted the themes of equality, development, and peace, intensified these commitments. The Fourth World Conference on Women, to be held in Beijing in September 1995 and which coincides with the fiftieth anniversary of the United Nations, will, like that anniversary, further reinforce these commitments.

A seminar attended by United Nations officials, delegations of governments, and representatives of nongovernmental organizations was held in Vienna in May 1995 on the topic "Women and the United Nations: Reflections and New Horizons." The seminar, organized by the Forum of Women Professionals to commemorate the fiftieth anniversary of the United Nations, was chaired by Dr. Filomina Chioma Steady, special advisor to UNIDO on the integration of women in sustainable industrial development for the Beijing conference and former special advisor on women to Maurice Strong, secretary-general of the Earth Summit.

The main objective of the seminar was to reflect and deliberate on the prospects and challenges of international development cooperation from a gender perspective and within the institutional framework of the United Nations system. Major issues that have been dominant in the UN agenda for women were examined in light of the UN's role as a catalyst in the advancement of women. The seminar also critically examined the UN's progress as a role model in improving the status of women within the organization.

Discussions also focused on the role of the UN as a symbol of collective global security not only in military but also in human terms. Among the important aspects of this security is the need to establish a just and equitable society by promoting sustainable human development.

The time to eliminate all obstacles to the advancement of women at the international, national, and community levels as well as in the home is long overdue. Innovative ways to challenge myths and taboos that confine women to traditional roles and to increase their participation in decision-making processes at high policy levels are essential requirements for social and human development.

One important overall goal of the Vienna seminar was to arrive at recommendations that would contribute to an enabling environment for the advancement of women through the eradication of the root causes of inequalities within and between nations and between men and women.

It was generally agreed that the persistence of the structural and personal disadvantages experienced by women in many countries requires intensified action on many levels. To this end special measures were considered essential for the enforcement of women's legal access to productive and social resources. Action was also considered necessary to accelerate the reform of legal and institutional structures to promote women's equal rights and responsibilities, including decision making at all levels. At the thirty-ninth session of the Commission on the Status of Women, which met in New York in March and April 1995, a resolution reinforcing the plan of action was adopted entitled "Improvement of the Status of Women in the Secretariat" (see Appendix).

The UN Decade for Women culminated with the Nairobi Forward-Looking Strategies for the Advancement of Women (NFLS), which

emphasized that women should be an integral part of the process, not only of defining the objectives and modes of development, but also of developing strategies and measures for their implementation. The organizations within the United Nations were given a decisive role in the implementation of the NFLS.

Strategies were endorsed for international and regional cooperation, which includes technical cooperation, training, advisory services, international coordination, research and policy analysis, technical cooperation, and information dissemination and monitoring. At the fourth World Conference for Women to be held in Beijing, the progress made in the implementation of the Nairobi Forward-Looking Strategies will be assessed and new recommendations proposed in the Platform for Action.

The Vienna seminar addressed such issues as the advancement of the gender dimension in all aspects of the UN agenda for equality, development and peace; the elimination of economic and social discrimination against women; the participation of women in technological advances, particularly information technology; women's role in field operations; the implications of technological change for women's health and the environment; improvement of the status of women in the UN system; and the participation of women in economic and political decision making. The seminar also stressed the importance of networking by using the expertise and influence of women in the UN system to advance a more gender-sensitive agenda for action on the promotion of equality, development, and peace. The seminar concluded with proposals of action-oriented recommendations to be presented as an input to the Beijing conference.

THEMES OF THE SEMINAR

Theme papers were presented, followed by panel presentations and discussions. The main points from the discussions are summarized below, and theme papers are presented in the ensuing chapters of the book.

Gender in Development: A Critical Issue for Sustainable Development

The most pressing development issues continue to marginalize women and render them invisible in terms of productivity and

wealth creation. We need a more balanced approach that will focus on both substance and process and bring women's contributions to the fore. Such an approach will emphasize gender relations and will be presented from an interrelated and comparative perspective.

The goal of Gender in Development (GID) should be to contribute to the empowerment of women and gender equity. Mainstreaming is essential, but issues specific to women should not be ignored. Gender as an analytical tool is important because it cuts across race and class. The challenge for international experts is to ensure that gender does not become a term used by the elites only. We need to set in motion a two-way process of communication between women at the grassroots level and academics, scholars, and development experts. International conferences have raised global consciousness, but rural and grassroots women have not been included in them. We need to integrate rural women more fully in national and rural plans of action.

Women: An Invaluable Asset in the United Nations System's Field Operations

Women in field operations encounter several challenges. In some respects, women with the experience of working on gender issues and with a commitment to those issues can play an important catalytic role in the field. Gender-sensitive women field officials, directors, and resident representatives can promote a number of initiatives, including support for women's ministries, introducing gender and development programs, and changing stereotyped attitudes and mind-sets. Women resident representatives with experience on gender issues can be a driving force, but they must have access to funding specifically earmarked for women's programs. Women's ways of doing things tend to be informal, which can be an asset in field operations and can facilitate networking and strategizing. In general, women are in a more privileged position to coordinate the field situation because they tend to consult rather than compete.

The Impact of Information Technology on Women

The pace of acceleration in information technology is unprecedented in the history of humanity. By the end of the century, electronics will be the largest industry. The explosion of information technology

could create opportunities for women, but as of now it is essentially a male-dominated field. There are great gender disparities among users. Only 15 percent of the Internet's thirty million users are women. Wide geographical disparities also exist, and the information highway operates mainly in industrialized countries.

Technical assistance should allow women in developing countries to become more involved in information technology. Access to information technology will be beneficial for women in general; as with all problems of access for women, however, gender-based discriminatory practices have to be abolished through legal provisions and enforcement. The trend toward home-based technologies can lead to further confinement of women. Care must be taken to ensure that technology is not used as a pretext to confine women.

As technology becomes more complex, women are being marginalized. They are also not involved or consulted in the design of technologies, which is controlled by white males. Elements of gender disparities are at play that need to be addressed.

The Beijing conference will provide an opportunity to lobby and influence governments on this issue. The gathering of nongovernmental organizations (NGOs) can influence other women and promote the dissemination of information. Women should prepare themselves for proper training and for acquiring management tools and building partnerships. They should accentuate their efforts and use the UN system to facilitate their collaborative efforts on promoting information technologies for women.

Improving the Status of Women in the United Nations System

The United Nations has been more successful as a catalyst than as a role model for the advancement of women. Its efforts to improve the status of women in the system have not lived up to Article 8 of the UN Charter. Change is necessary not only to achieve gender parity but also to promote a better gender balance of management styles.

Progress in ensuring women access to senior-level posts has been slow and will not likely reach the targets set for the immediate future, which include a 50 percent representation of women in senior positions by the end of the fiftieth-anniversary year, 1995. The present rate of promotions shows that more men than women have

been promoted at the senior levels (P–5 through D–1) and more women than men have been promoted at the lower levels (P–2 through P–4). The objectives of the 1994 strategic plan of action established targets of 35 percent overall representation of women in posts by 1995 and 25 percent at the D–1 level and above no later than June 1997.

There is also an imbalance among regions. North America and the Caribbean have the highest representation of women, followed by Western Europe, Asia, and the Pacific. Western Asia, Eastern Europe, and Africa have the lowest female representation.

Among the problems identified are the tensions between geographical balance and gender balance; lack of an "old girls" network; women not supporting other women; sexual harassment; insufficient gender-sensitization training of the staff; lack of sufficient women on task forces; and the need for a change in the mind-set of men. Action should center around strategic staffing plans, succession plans, and training programs. In addition, women should be made to feel a part of the team and be more assertive about their career advancement.

The Woman Entrepreneur: The Challenges in an Agenda of Globalization of Enterprises

In the globalization of enterprises, outside market forces are in command. The effect on women can be both negative and positive. Integration, standardization, and the flow of free trade depend on competition, which puts women at a disadvantage because of their generally weaker economic position. On the other hand, the decentralization of production and the breakdown of trade structures may prove advantageous to women. It is important to establish procedures and legislation that allow for greater flexibility: when dealing with women as entrepreneurs and as managers it is better to avoid too much rigidity.

The major challenges to women in the globalization of enterprises is access to decision making and ensuring their economic independence. The key to strengthening women entrepreneurs is networking. Access to information on consumption patterns and different lifestyles is also important, as is "intrepreneurship," which is the training of entrepreneurs from inside.

Women bring to business their patience, their sense of responsibility, and their multidimensional approach to tasks. A woman's ability to handle diverse tasks at the same time is reinforced by her determination and attention to detail as well as by her strong sense of responsibility.

Women in the Global Labor Market: Empowerment and Enabling Environment for Progress

Two of the major challenges resulting from globalization of the labor market are the disappearance of the national labor market and the blurring of distinctions between the formal and informal labor markets. There is an increasing feminization of the labor market, and women's participation is decisive. The working woman of today is a committed worker.

Major transformations are also taking place in production. Investment flows determine globalization trends, technological information, economic reforms, liberalization, and demographic changes, all of which have implications for women's participation in the labor force. Opportunities have been created, but so have risks and insecurities.

On the positive side, women's level of economic participation in most regions has risen dramatically. On the negative side, such increase has not necessarily resulted in better working conditions or a higher quality of employment. Effective action will be required to create an enabling environment for promoting equal opportunities and treatment for women in employment as well as enforcing international conventions and promoting unionization.

The United Nations system can play the role of international advocate to promote an enabling environment for women workers. It can also provide technical advice; promote the exchange of experiences among states; strengthen collaboration among employers, employees, and trade unions; serve as a role model in the treatment of women within a system; disseminate information on women's education and women's rights; and collect the data on female employment.

Financing Women in Development Programs: An Agenda for Change

The United Nations is moving from economist models to human development models, with sustainability as an essential goal. Among

the many constraints to achieving these new objectives are obstacles in the conventional means of financing adjustment programs. Sustainability requires us to focus on macroeconomic development on a long-term basis and to regard investing in women as an engine of growth that will also increase the productivity of men. In some countries, 50 percent of entrepreneurs are women in micro and small-scale enterprises that can stimulate the formal economy.

We urgently need to develop small-scale credit schemes and local indigenous credit systems for the urban and rural poor. Financial institutions must also be reformed to make loans to women who tend to have very good repayment records. We also need to refocus the macroeconomic dialogue on long-term development that stresses growth with equity and allows women to take their rightful place in the development equation.

Women, Technology, Health, and the Environment

Negotiations for the transfer of technologies to developing countries are often conducted at higher levels without concern for the views of the people, especially women, in these countries. The result is an indiscriminate dumping of technologies in developing countries. The transfer of environmentally unsound technologies can destroy the ecological balance by contaminating air, soil, and water. Some chemical pesticides contain carcinogenic substances of which users are usually not aware. The United Nations Industrial Development Organization (UNIDO) is currently trying to introduce biodegradable and environmentally safe biopesticides to developing countries.

The UN system and other international organizations play an important role in promoting industrial education for women that can strengthen their knowledge and enable them to select the best technologies without jeopardizing the environment.

Sustainable development—development without damage to the environment—should promote human well-being and dignity as well as equity and social justice. The 1992 Earth Summit in Rio de Janeiro was a turning point. *Agenda 21: The United Nations Programme of Action from the Earth Summit* called upon the world to examine gender issues in relation to sustainable development. Yet implementation is not happening, and women are not being integrated in programmatic developments.

SUMMARY

These themes are all reflections of various issues that constitute the UN agenda for women but by no means represent the total agenda being implemented by various agencies within the UN system. Many activities of the United Nations have inputs from nongovernmental organizations and women's groups. The seminar benefited from the participation of NGOs as well as governmental delegations, including ambassadors. The next millennium will likely witness an expansion of the UN's role in development activities and the increasing participation of nongovernmental organizations, hopefully indigenous ones. The partnership of the UN with NGOs is particularly important to promote gender-sensitive and sustainable development programs for women and to advance the agenda for equality and peace.

This book presents the proceedings of the May 1995 Vienna conference. It is divided into five parts. Part I contains a paper on the background and history of the fifty-year alliance of the UN and women. Part II contains the theme papers, part III the statements and speeches, and part IV the recommendations. The Appendix reproduces three resolutions drafted at the thirty-ninth session of the Commission on the Status of Women, which met in New York 15 March–4 April 1995. It also contains notes on contributors and a list of panelists.

The view expressed in this book are those of the authors and do not necessarily reflect the views of the United Nations system.

Royalties from the book will be donated to UNIDO's operational projects for women.

PART I

BACKGROUND

1

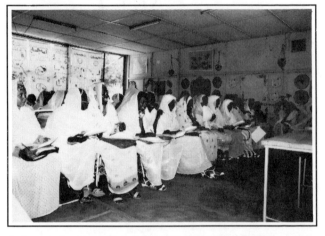

College students attending an FAO World Food Day Seminar on "The Role of Women in Agriculture" in the School Gardening and Nutrition Center, Khartoum, Sudan. Photo by Leena M. Kirjavainen.

\mathcal{T}HE UNITED NATIONS AND WOMEN
An Alliance of Fifty Years
Filomina Chioma Steady

IMPLEMENTATION: A GLOBAL CHALLENGE

The half century since the founding of the United Nations has seen many promises made to women. Yet as we approach a new century and a new millenium, our challenge is how to implement the thousands of dormant commitments made in declarations, plans of action, conventions, and resolutions pertaining to women. For example, the earliest convention concerning the status of women was adopted in 1949 "for the suppression of traffic in persons and the exploitation of the prostitution of others." Forty-six years later, in 1995, the UN's Commission on the Status of Women (CSW) still found it necessary to adopt a resolution on traffic in women and girls (see Appendix).

Women no doubt are hoping that both the fiftieth anniversary of the UN and the Beijing conference will accelerate the demise of all remaining obstacles to their advancement and herald the dawn of a new millennium—the millennium of implementation. In this new millennium we may hope that economic growth will be informed by gender-sensitive policies and be accompanied by equitable human and social development programs that guarantee ecological security. We may also hope that all women will be in a position to have achieved self-knowledge and awareness; guaranteed legal rights and access to productive resources, education, and training; enhanced self-esteem and self-confidence; and above all, self-determination.

THE EARLY YEARS

The issue of women's rights has been on the international agenda since the Paris Peace Conference of 1919, which established the League of Nations. Women's rights were included in the United Nations Charter thanks to the work of women's organizations and the efforts of individual women. One outstanding woman was Minerva Bernardino, a delegate from the Dominican Republic (Karl 1995). In 1946 the Commission on the Status of Women (CSW) was formed and influenced the drafting of the Universal Declaration of Human Rights. This declaration was drafted by the Commission on Human Rights which was chaired at the time by Eleanor Roosevelt. Adopted in 1948, it guaranteed fundamental human rights to everyone in Article 2. "Everyone is entitled to all the rights and freedoms set forth in this Declaration, without distinction of any kind, such as race, colour, sex, language, religion, political or other opinion, national or social origin, property, birth or other status."

Women's international organizations provided the main stimulus for gender-sensitive change in an international system that was then and still is largely dominated by men. In many developing countries, women were joining forces with men in nationalist movements for independence in the struggle to end colonization. Their efforts also helped augment concepts of human rights and became part of a major UN project on decolonization.

As an instrument of peace, the United Nations was the creation of those who had been at war and were desperate to ensure global security through negotiation rather than through weapons of destruction. Although not obvious at the time, the agenda for women's equality and rights was to become an essential element in the quest for peace.

A substantial aspect of the CSW's work can be attributed to external pressures from women's organizations and conceptual models provided by academic and research institutions. Through the CSW's work, several conventions were drafted related to the improvement of the status of women. These culminated in the Convention on the Elimination of All Forms of Discrimination, which was adopted by the General Assembly in 1979 (Pietila and Vickers 1994).

This year marks the fiftieth anniversary of the United Nations and the forty-ninth year of the CSW, an intergovernmental policy "think tank" within the Economic and Social Council (ECOSOC), which has been mainly responsible for the women's agenda in the United Nations system. The secretariat for the CSW is the Division for the Advancement of Women, a part of the United Nations secretariat in New York. Until recently it was located in Vienna as part of the former Center for Social Development and Humanitarian Affairs.

INTERNATIONAL WOMEN'S YEAR AND THE UN DECADE FOR WOMEN

International Women's Year was declared in 1975 and the UN Decade for Women from 1976 to 1985. The goals and targets of the decade were outlined in the Declaration of Mexico and its Plan of Action. The United Nations has since held three World Conferences on Women, in Mexico City (1975), Copenhagen (1980), and Nairobi (1985), each producing a plan or program of action for the advancement of women through promoting equality, development, and peace. An NGO tribune or forum has traditionally been held parallel to each of the official conferences and has provided an opportunity for networking and for a less restrained and more dynamic engagement among women. By the end of the UN Decade for Women, three main UN institutions had been established and consolidated to represent three pillars of the decade.

The first pillar was the existing Branch for the Advancement of Women, later to be renamed the Division for the Advancement of Women. It was primarily responsible for servicing the CSW and the Committee on the Elimination of All Forms of Discrimination against Women. The second pillar, the United Nations International Research and Training Institute for the Advancement of Women (INSTRAW), was established to promote research, training, information services, and the participation of women in public life. The third pillar, the Voluntary Fund for the Decade for Women, later renamed the United Nations Development Fund for Women (UNIFEM), was established to fund innovative and catalytic projects of women in developing countries.

In addition, most UN organizations and specialized agencies have developed programs for women over the years, some of which

have been coordinated through a systemwide medium-term plan on women in development and interagency mechanisms. UN agencies have also collaborated to produce the World Surveys of the Role of Women in Development and *The World's Women,* a publication on trends and statistics on women.

THE FOURTH WORLD CONFERENCE FOR WOMEN: ACTION FOR EQUALITY, DEVELOPMENT, AND PEACE, BEIJING, 1995.

The main objective of the Beijing conference to be held September 4–15, 1995, is to negotiate a draft Platform of Action whose aim is "to accelerate the implementation of the Nairobi Forward-Looking Strategies for the Advancement of Women to the year 2000 and the removal of all obstacles to women's active and equal share in economic, social, cultural and political decision-making."

As is characteristic of all UN conferences on women, it will also review and appraise the progress made in the implementation of the previous program of action, in this case the Nairobi Forward-Looking Strategies (NFLS) and the 1994 World Survey on the Role of Women in Development.

A parallel meeting of nongovernmental organizations (NGOs), the NGO Forum, will be held from August 30 to September 4 in Beijing. NGOs will conduct hundreds of sessions and events related to critical areas of concern and lobby governments to ensure that their priorities are included in their negotiations.

IMPLEMENTATION OF THE NAIROBI FORWARD-LOOKING STRATEGIES FOR THE ADVANCEMENT OF WOMEN

Monitoring and evaluating UN system activities, as required by the NFLS, means finding ways to analyze the situation of women in different geographical areas. All agencies are also required to include progress made in implementing the NFLS in their reports to their respective governing bodies and the CSW.

Special attention to the issue of women's roles in development has always been necessary because many women continue to experience limited access to essential resources. Legal and institutional structures must be reformed in order to guarantee women equal rights and responsibilities, including decision making at all levels. Although the gender gap has narrowed slightly in public life and leadership posi-

tions, the record of women in decision-making positions in political organizations and in economic decision making worldwide has remained poor (World Survey on the Role of Women in Development 1989, 1994).

The question of the advancement of women and the need to eliminate both de jure and de facto discrimination against women continue to receive high priority in UN circles. Some noteworthy progress has been made in the ratification of international instruments, particularly the Convention on the Elimination of All Forms of Discrimination against Women, which has now been ratified by 139 countries. Several other conventions of the International Labour Office (ILO) and the United Nations Educational, Social, and Cultural Organization (UNESCO) also contain provisions for ending discrimination against women in education and employment and with regard to the protection of workers. Nonetheless, de facto discrimination against women still exists in many countries (Ibid.). It has been pointed out by the United Nations and some specialized agencies that in addition to problems of de facto discrimination women are also affected by problems of invisibility. National statistics do not often reflect women's contributions in many areas such as the informal sector, unpaid family and nonfamily labor, and home-based work for industries.

Because women's contributions are not accurately recorded they are not given sufficient consideration in the formulation of development policies. For example, several studies have shown how biases inherent in agrarian and rural development approaches have led to inadequate analyses of women's reproductive role and resulted in undervaluing women's contributions to development (FAO 1990). A review of UN activities affecting women in environment and development revealed the need for promoting awareness of the structural linkages relating to women, environment, and development as an essential aspect of program development (Steady 1992). The first review of the implementation of the NFLS concluded that although "considerable progress had been made in recognizing and eradicating legal discrimination against women, discrimination still existed in practice in all countries, regardless of their level of development."

The review and appraisal of the NFLS for the Beijing conference will be based on national reports and available statistical data from the UN system and other relevant governmental and nongovernmental sources.

The review format follows the structure of the Platform for Action. Based on indications from the 130 national reports submitted for the conference by January 1995, implementation continues to be a challenge for most countries, particularly for countries in the developing world. Many developing countries are confronted with chronic economic problems and are subject to such constraints as the debt burden, the decline in commodity prices, reverse resource flows, structural adjustment conditionalities, and general globalization trends, all of which put them at a disadvantage in the world economy.

WORLD SURVEYS OF THE ROLE OF WOMEN IN DEVELOPMENT (1986, 1989, 1994)

The 1989 World Survey noted that the economic crisis of the 1980s had "a differential impact on women often with disappointing results affecting all aspects of women's lives." It also noted that "in agriculture, positive effects such as increases in prices are often offset by the introduction of new technologies which for cultural reasons are used primarily by men. In industry, women's employment increased, but often in lower paid categories, and these increases have not been matched by access to economic decision making. Even the growth of the service sector, which has proved to be the most resistant to the economic crisis, has not always benefitted women. In the informal sector, into which women seem to have retreated, exploitation of women's political and economic weakness have often led to new forms of discrimination" (World Survey 1989).

The 1994 World Survey reported two major changes over the last ten years that have facilitated an enabling environment for women in the economy. These were changes in women's legal status and changes promoting equal access to education and training for women. It noted also the substantial increase of women's participation in the paid labor force and repeated that such increases in the economy and in female educational enrollment have not been reflected in women's participation in economic decision making (World Survey 1994).

SYSTEMWIDE MEDIUM-TERM PLAN ON WOMEN AND DEVELOPMENT

A systemwide medium-term plan on women and development implemented by thirty organizations resulted in an increase of

funding for activities and programs for women by fourteen out of twenty-three organizations that reported to the CSW for the period of 1990–91. However, a decrease in funding was also reported by nine organizations between 1988 and 1991 (UN 1991).

UN General Assembly resolution 45\129 requested that, in formulating the systemwide medium-term plan for 1996–2001 and in integrating the NFLS into activities requested by the General Assembly, the secretary-general pay particular attention to the strengthening of national machineries for the advancement of women and to the specific sectoral themes integral to the objectives of equality, development, and peace. It also requested that special attention be paid to improving the situation of women in the following areas: literacy, education, health, population, environment, and the full participation of women in decision making. The future systemwide medium-term plan on women and development (1996–2001) will be prepared and revised in light of the outcome of the Beijing conference. It is hoped that all organizations in the UN system will increase their allocation of resources to programs designed to promote the advancement of women.

The seven programs containing twenty-six subprograms of the proposed systemwide medium-term plan for the advancement of women for the period 1996–2001 (UN 1993) are as follows:

- Elimination of legal and additional forms of discrimination

- Productive resources, income, and employment

- Human resource development

- Promotion of peace and resolution of conflict

- Decision Making

- Improving the means of international action

- Role of women in sustainable development

From WID to GID: In Keeping with the Systems Approach

One major conceptual shift in the area of development has been the shift from "Women in Development" (WID) to "Gender in Development" (GID). The first approach, which is still used in field operations, emphasizes the integration of women in development by

ending gender-based discrimination and facilitating equal access for women to resources, legal rights, opportunities, and so on. This approach guided most UN programs on women and development until recent times. It promotes women-specific projects as well as projects aimed at incorporating women more fully into mainstream development. It tries to ensure that women are counted or added on as a means of their integration in development (UNRISD 1995). The qualitative aspects of their integration as well as the sustainability of such integration were not major concerns in the early stages of WID, but their importance became apparent later. They remain among the relatively underdeveloped areas of the approach.

The GID approach has no single operational definition and does not completely replace the WID approach. It views inequality between men and women as structural, dictated by sociocultural norms that serve as organizing principles of society. It argues that the piecemeal method of integrating women in development should be replaced by measures to change the structural relations between men and women that are socially determined and keep women in a position subordinate to men. The GID approach is also struggling with the methodological challenges posed by improving the quality and sustainability of women's participation in development.

This holistic orientation of the GID approach is in keeping with the trend toward more systems-oriented approaches to development. The increasing stress on the need to link sectoral and cross-sectoral issues in relation to development has guided recent approaches to development. The Earth Summit held in Rio in 1992 exemplified this need best in developing programs for sustainable development and in its adoption of *Agenda 21,* which links environment to development. The same is true of the International Conference on Population and Development and the World Summit for Social Development.

The major challenge to the emphasis on GID lies in the realities of implementation, which is the sine qua non of all development policies and programs. Program development must take cultural constraints into account. GID aims to address gender relations in such a way that programs have a positive effect on women as well as men, but applying GID strategies during the implementation phase can pose enormous practical challenges.

Implementation is often conditioned by the social and cultural realities in the field, thereby making multilateral interventions difficult. In

many developing countries, gender relations often necessitate the operation of men and women in separate but economically integrated spheres. Change in one sphere often has to be accompanied by corresponding change in the other sphere. If the GID approach keeps pace with the practical difficulties of implementation, it can help ensure that social and human development for both men and women becomes the main goal of economic growth and development.

Mainstreaming gender issues into all areas of development is still experimental in many countries, and no definitive evaluation has yet been undertaken to determine its success, failure, or general prognosis. Furthermore, some women from developing countries, many of whom have just begun to implement projects and programs using the WID approach, have expressed their difficulty in identifying with the GID approach at international meetings by virtue of the reduced stress on the word *women*. It is also not clear how the methodologies of the GID approach are going to be implemented and institutionalized.

It is therefore likely that both the WID and the GID approaches—which are not mutually exclusive—will be used in many parts of the world for a long time to come. When change is introduced based on analytical models and perspectives originating from outside, indigenous perspectives and models are likely to play a major role in shaping the ultimate outcome of such approaches.

INTERNATIONAL STANDARDS AND THE PREEMINENCE OF CULTURE

Despite several points of convergence within the international community in promoting international standards, tensions between international standard-setting objectives and the preeminence of cultural norms are evident in most UN deliberations. To a large extent they represent tensions between two dominant trends in the modern world: the emphasis on sovereignty and the imperatives of globalization. Both trends have been reinforced by the demise af the cold war, the weakening of the nation-state, and the resurgence of ethnic cleavages and racism.

Recent international conferences such as the Human Rights Conference and the International Conference on Population and Development have witnessed the resurgence of "cultural considerations" as a basis for making reservations to specific recommendations being

proposed for agreement by consensus. Cultural definitions of human rights vary, as the World Conference on Human Rights demonstrated. While some countries represented at that conference placed a greater emphasis on the social and economic aspects of human rights and group-focused guarantees, others stressed political and public rights and the rights of the individual. Also, many of the reservations made on articles in the Convention on the Elimination of All Forms of Discrimination against Women are related to conditions that require change in institutions of marriage, the family, inheritance systems, and political participation, which are often based on cultural traditions.

In most human societies, culture has a mediating influence. Plans of action developed by intergovernmental bodies at international conferences or as the General Assembly are subject to this influence particularly at the time of implementation. Culture has tended to determine gender roles and expectations and is often the dominant normative framework through which social relations are organized. Laws, constitutional provisions, and administrative procedures, while essential, have only a limited capacity to bring about lasting change without corresponding changes in culture—the collective system of rules and regulations that provide a guide for living to members of any given society.

FROM EQUALITY, DEVELOPMENT, AND PEACE TO CONCERNS FOR ALL HUMANITY AND THE PLANET

Although the three Decade for Women themes of equality, development, and peace are conceptually integrated and interdependent, each theme has assumed priority at a given time. The earlier emphasis was on equality, the end of de jure discrimination, and women's political rights. With varying degrees of success, progress has been made in promoting equality based on changes in legislation (World Survey 1994). The stress on political rights extended beyond gender concerns and included the involvement of women in eliminating racism, apartheid, racial discrimination, colonialism, alien domination, and acquisition of territory by force (United Nations 1976, agenda item 8).

The middle and end of the Decade for Women tended to stress development; expanded the definition to include not only economic

development but also social, humanitarian, and moral aspects; and gave priority to women who were particularly vulnerable. The emphasis on women's economic roles expanded the role of the specialized agencies of the UN system in integrating women in development. Overall progress in the field of development has been mixed, as exemplified in the need for a fourth United Nations Development Decade and an Agenda for Development. Though some progress has been made in involving women in development, it has often been undermined by recessionary trends, debt burdens, decline in commodity prices, economic reform, and the general constraints of globalization.

In the postdecade period, concerns with the theme of peace have assumed major significance as armed conflict, civil strife, and territorial disputes dominate the international landscape and produce millions of refugees, the majority of whom are women and children (see Appendix). Among the current period's encouraging stories are the political victories of the South African and Palestinian liberation struggles, which were heroically championed by women at the 1985 Nairobi conference. The emphasis on peace corresponds to the UN's general trend to assume a more prominent but controversial role in peacekeeping.

At another level, women are redefining the notion of peace within the context of human rights. When viewed through the prism of gender, peace and human rights issues have become inseparable, and both have implications for the public as well as the private domain. Domestic violence was systematically introduced to the UN intergovernmental process during the Copenhagen conference as a health issue. It later was included during the Nairobi conference in a chapter on fourteen areas of special concern. Now it stands on its own as a critical area of concern in the Platform for Action. This will strengthen the implementation of the Declaration on the Elimination of Violence Against Women adopted by the General Assembly in 1993.

The effect of environmental degradation on the planet, on humanity, and specifically on women has been another area of concern in the postdecade period. The Earth Summit was a breakthrough in terms of the extent to which a major mainstream conference was able to integrate women's concerns in its declaration, its program of action, as exemplified by chapter 24 of *Agenda 21*, "Global Action for

Women toward Sustainable and Equitable Development." In addition, women were recognized as major players in action to promote sustainable development.

Each stage of evolution of women's issues has thus revealed increasing concerns about problems that are not strictly women's issues but have implications for the whole of humanity and the planet (Steady 1993). The complexities that they reveal underscore the need for solving universal human problems and for promoting sustainable development.

Each stage has also strengthened the role of NGOs in influencing the process of negotiation by governmental delegates and in setting their own agenda so that issues become less diluted and convey a sense of urgency. NGOs are generally more motivated to champion controversial causes, and indigenous NGOs have been quite successful as important partners in the implementation of development policies and programs.

In the final analysis, the best guarantee for peace is an agenda for development that promotes economic growth in a manner that is ecologically sound, equitable, people centered, gender sensitive, and sustainable.

REFERENCES

Food and Agricultural Organization. 1990. "Women in agricultural development." In *FAO's Plan of Action*. Rome: FAO.

Karl, M. 1995. *Women and Empowerment: Participation and Decision-Making*. London: Zed Books.

Pietila, H., and J. Vickers. 1994. *Making Women Matter: The Role of the United Nations*. London: Zed Books.

Steady, F. 1992. *Activities of the United Nations System on the Role of Women in Environment and Development*. United Nations Conference on Environment and Development research paper no. 41. Geneva: UN.

Steady, F. C. 1993. *Women and Children First: Environment, Poverty, and Sustainable Development*. Rochester, Vt.: Schenkman Books.

United Nations. 1976. *Report of the World Conference on International Women's Year*. New York: UN.

————.1985. *The Nairobi Forward-Looking Strategies for the Advancement of Women*. New York: UN.

————.The World Survey on the Role of Women in Development, 1989, 1994. *The World's Women*. New York: UN.

————.1991. "Implementation of the system-wide medium-term plan for women and development." In *Report of the Secretary-General*. New York: UN.

————.1993. *Proposed Systemwide Medium-Term Plan for the Advancement of Women for the Period 1996–2001: Note by the Secretariat*. New York: UN.

United Nations Research Institute for Social Development (UNRISD). 1995. "From WID to GID: Conceptual Shifts in the Women and Development Discourse," *Occasional Paper*. Geneva.

—Chair, Special Advisor on Women in Sustainable Industrial Development, UNIDO

PART II

THEME PAPERS

2

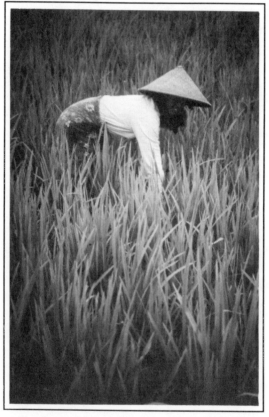

Indonesian farmer tending rice crop. FAO/Peyton Johnson.

Photo by Kai Nordberg

\mathcal{R}URAL WOMEN, FOOD SYSTEMS, AND AGRICULTURE
Issues and Challenges beyond Beijing

Leena M. Kirjavainen

WOMEN IN AGRICULTURE AND RURAL DEVELOPMENT

For nearly 50 years, the UN Food and Agriculture Organization (FAO) has assisted member nations to raise levels of nutrition and standards of living, to improve production and distribution of food and agricultural products, and to better the condition of rural populations, thus contributing to ensuring the world's freedom from hunger. However, there is no freedom from hunger in a world where, according to UN estimates, more than one billion people live in abject poverty and most of them go hungry every day. Some 800 million have inadequate access to food. Most of the world's poor live in the least developed countries, which are predominantly rural. In 1992 about 80 percent of all people in the poorest countries lived in rural areas, and social development indicators show that the majority of the poor are women. In the poorest, predominantly rural countries, women have lower life expectancies and higher illiteracy rates than women in more developed countries.

Poverty and lack of opportunity in rural areas has also contributed to negative sociodemographic trends, including the unbalanced spread of population between rural and urban areas. The rural emigration (especially of males) is linked to the search for economic

opportunities and has contributed to the feminization of agriculture. Moreover, the increase in the number of women-headed households (which globally now account for 30 to 40 percent of all households) has also contributed to the feminization of poverty. Other trends include growing social and environmental problems associated with sprawling urban centers, and the growth of rural populations as those remaining on the land seek to expand the available labor pool and to provide for a human-based safety net.

It is therefore accurate to say that the most disadvantaged population in the world today are poor rural women, who have been the last to benefit—or have even been harmed—by economic growth and development processes. It is equally accurate, however, to say that because rural women are our most valuable asset in the development process, they play a critical role in agricultural production and environmental management. They are major contributors to food crop production, both for sale and for household consumption, and they engage in numerous other on- and off-farm productive activities, such as post-harvest processing and storage, livestock rearing, fish farming, and marketing. It is estimated that they provide nearly 40 percent of the agricultural labor in Latin America, 60–80 percent in Asia, and over 80 percent in Africa.

In addition, rural women are the major users and managers of agricultural resources and are the primary household managers. Despite these responsibilities, rural women and girls have less access to and control of productive and human capital resources than their male counterparts.

In view of these sociodemographic factors, the FAO has identified a number of special considerations that must be taken into account when formulating development programs and projects:

Women in Food and Agriculture Systems

Whether we look at Sub-Saharan Africa or the Caribbean, where women produce 60–80 percent of basic foodstuffs, or Asia, where they perform over 50 percent of the labor in rice cultivation, or Southeast Asia and the Pacific or Latin America, where their home gardens represent some of the most complex agricultural systems known, women have a major responsibility for, and knowledge of, food systems and agriculture.

World over, rural women are responsible for rearing small livestock and handling large livestock not maintained on free ranges. Women provide for household needs by gathering food, water, and fuelwood. Women possess vast indigenous knowledge enabling them to identify plants, roots, tubers, leaves, fungi, fruits, barks, and insects in microecological systems that are essential for their families' well-being. Women also provide most of the labor force and make decisions on all types of post-harvest operations including storage, handling, and marketing. Their labor is most frequently employed in off-farm food processing, either in microenterprises or as wage labor in agro-industries.

Women As Household Managers

Pooling the incomes of men and women is often essential to survival and family support. A number of studies show that the direct responsibility for household food provision falls largely on women. Also, in intrahousehold food consumption and distribution, female members often get less food than males both in absolute terms and in terms of nutritional requirements. Looking at the improvement of household-level food security and the nutritional well-being of family members, we see a direct link to women's access to income and their management of household resources.

The challenge is to promote a more equitable gender division of labor and decision making so that men take on greater responsibilities in the areas of household management and maintenance, food security, and child rearing.

Gender Bias and Gender Blindness

Rural women are not a homogeneous group. Diversity among rural women arises out of cultural factors related to religion, race, ethnicity, and social class. But poor rural women in the least-developed countries around the world do have much in common. This commonality comes from shared social positions, as well as gender bias and blindness.

Gender bias and gender blindness are evident throughout the world's agricultural and food systems. They are major causes of food insecurity and environmental degradation. In spite of the predominance of women's labor in many farming systems, and of a significant

and rising proportion of women-headed farms and households, gender blindness is obvious in the way that farming communities are portrayed. This can be noted both at the global and regional levels where sectoral policies are made, and also at the local level, where agricultural services are delivered. A farmer is usually seen as either genderless or male. One of the most striking examples of this is rural women's access to extension services which, worldwide, is only about one-twentieth that of men.

Without access to training and extension, women have a limited chance to raise productivity through improved technologies. Low agricultural productivity, combined with responsibilities for the family, community participation, and increasingly, various informal income-generation activities for the households they head or chiefly support (about 40 percent of all poor households), means that poor rural women work about a third more hours than men, for an average of some fourteen hours per day.

Access to Land and Insecure Land Tenure

Lack of access to land or insecure land tenure is a critical issue that many women farmers face. Landlessness and land concentration have increased as common property rights have broken down. Women's rights to land were generally assured under customary systems in regions where women were recognized as major agricultural producers. But over time, legal land tenure systems developed in the colonial states, replacing customary systems. In these legal systems, women's access to land and other resources became restricted or were made dependent on male authorization. In Thailand married women traditionally inherited their parents' land. Today the legal system requires that all land belonging to couples be titled in the husband's name. Women's land access tends to decrease with the expansion of monoculture cash crops, timber operations, and range cattle production. Furthermore, irrigation, resettlement, and agrarian reform programs typically exclude women as beneficiaries and can reduce their access to land.

Many studies show that women often have access only to the lowest-quality land and, at the same time, have insecure land, water, and tree tenure. This means that women will not be as likely to invest time and energy in tree planting, contour construction, and other

soils management measures needed on marginal land. Also, women without land title may not be eligible for credit or membership in farmers' organizations, which could enable them to gain access to inputs that can help to stabilize their production systems.

The priority is to infuence policy and decision makers to redistribute land to poor farmers, ensuring that women benefit both as farm heads and as wives; protect women's customary access to land; and promote a favorable legal environment for secure tenure.

Technology and Labor

The poor rarely benefit from agricultural mechanization and other labor-saving technologies. If rural wages are high, technologies are introduced to reduce the demand for labor. An example is weeding, which is done by hand until wages begin to rise, when mechanical and chemical methods are introduced. Then tractors are introduced, which permits the area under cultivation to be increased; if weeding is not mechanized or weed control measures are not introduced, the demand for women's labor in weeding increases. Ironically, it is primarily the rural poor who most need, but do not receive, the agricultural technology to reduce their workload and increase their productivity and incomes.

Most rural women are not paid for their work. Since technology is often introduced to reduce the cost of labor, there may be little incentive to introduce technology where labor is unpaid. In subsistence farming and domestic activities such as crop processing, the technology used tends to be constant over time, since those who have the incentive to increase productivity are the unpaid workers themselves, who have no access to income with which to purchase technology. The incentives for the research and development of appropriate technologies are often lacking, so they are usually not available, or women cannot afford them. This explains why, all over the developing world, it is common to find rural women using the same technologies, such as mortar and pestle, that they have employed for hundreds of years.

Without technology the need for unpaid labor remains high, making it difficult for women to look for paid employment even if it exists. The result is that women and other unpaid workers are overemployed in terms of time worked and underemployed in terms

of income received. It is common to find that a poor farmer may work fifty hours or more a week yet receive less than the minimum wage. A woman may work sixty or more hours a week between domestic, farm, and off-farm tasks, and yet receive no wages or cash income of any kind. In poor rural regions, the problem is compounded by a lack of infrastructure such as roads, electricity, water, and health, which increases the need for unpaid labor time, reinforcing the over/underemployment dilemma.

Because women are largely unpaid or are paid lower wages, it is typically male tasks that are mechanized while female tasks remain nonmechanized, with the net result that often women's labor burdens are actually increased through mechanization. Further, in those cases where typically female tasks are mechanized (such as crop processing and market transport), these often become men's tasks, whereas women are left with the remaining nonmechanized work and stop receiving income they may have earned. The negative impact on family welfare is compounded, since income received by women is usually spent on child nutrition and family needs.

The challenge is to encourage both public and private sectors to involve the end users, both men and women, in the determination of research priorities and in the design and implementation of technology programs. The potential of women's local knowledge systems and of blending modern and traditional techniques must be recognized and incorporated into these programs.

The lack of employment opportunities in rural areas also gives rise to seasonal or permanent emigration. In many regions, rural men emigrate in search of wages, a situation that has increasingly left women in charge of farms and rural households, with less family labor available and greater responsibilities, but with little improvement in their access to resources. While remittances sometimes place woman-headed households in a relatively privileged position, these remittances often decrease when men are absent for long periods.

Women, Environment, and Food Security

Rural women's relation with the environment is derived from their fundamental historical and cross-cultural role as household managers and providers of basic foodstuffs, fuel, and water for their families.

Indeed, the relation between women and the environment can be conceived as rooted in their concern with household food security. Changes in tree and land tenure, land use, and technology are viewed by women according to their effects on the water supply for domestic and small-scale irrigation; on the possibilities for gathering fuelwood, fodder, medicinal plants, and insects; and on tree, plant, and animal production for consumption and sale. The fodder they gather from natural grasslands and forests feeds the livestock that produce the dung they place on their fields to maintain soil fertility. The potable water used for the household can be reused to irrigate plants.

Rural women are both the best equipped and the least equipped to manage the environment. They are the best equipped with determination and indiginous knowledge. They are the least equipped because they usually have no voice or vote in large-scale decisions affecting their natural environment. Even their traditional knowledge is becoming less of a resource as conditions around them change: some techniques become dysfunctional as ecological conditions deteriorate, some are lost from one generation to the next, and some simply cannot be applied owing to lack of time and other resources.

Biodiversity and Genetic Resources

Biodiversity describes the diversity of all forms of life on earth—plants and animals, species, and ecosystems. In the developing world, biodiversity provides the assurance of food and countless raw materials for clothing, shelter, fertilizers, fuel, and medicines. The FAO is very interested in that part of biodiversity that nurtures people and contributes to long-term food security for all.

Because of their knowledge of forests, crops, soils, water management, medicinal plants, growing techniques, and seed varieties, women are major caretakers of agricultural and livestock genetic resources, identifying, preserving, and using wild and domestic species to provide household food for their families. Agricultural practices that reduce the availability of these resources include mechanical land clearing, plowing and weeding, and the use of pesticides.

As international demand for the crop and livestock products of developing countries expands and production systems become

modernized, women are especially affected. As new consumption patterns (wheat bread and street foods) and market incentives (such as for hybrid corn or rice) are introduced, these traditional resources and knowledge have tended to disappear. Women have become dependent on purchasing imported foodstuffs and on producing varieties and breeds that are less resistant to local diseases, pests, and climatic change. Often this has increased their need for cash to buy foodstuffs, as well as their vulnerability to market failure, drought, and famine.

The challenge here, beyond protecting ecosystems, is to recognize women's roles, rights, and knowledge in genetic resources management; forge new parterships between women farmers, researchers, and extension services to promote the protection and appropriate use of biological diversity; and create policies and practices that encourage the preservation and consumption of local species.

Reorienting Agricultural Policies and Services

What is needed to reorient agricultural programs so that these become people centered and gender responsive and thus contribute toward the advancement of rural women, food security, and sustainable resource use? The essential requirements are:

> a comprehensive, interdisciplinary, and dynamic understanding of the relations between women, food, agricultural systems, and the environment that is relevant to national reality;

> a continuous dialogue between rural women and the different actors involved, such as policy makers, service providers, and local change agents; and

> a reorientation of developmental goals, policies, and actions to accommodate what is learned.

These are inseparable processes: goals and policies must change to permit this reorientation, and only through dialogue will the dynamic relations relevant to rural women's advancement become evident. Such reorientation recognizes, first and foremost, not only that women are capable and dynamic managers of very difficult life situations but also that they are actively seeking social change through cooperation, organization, mobilization, and learning.

LINKING LOCAL AND GLOBAL: THE ROLE OF INTERNATIONAL DEVELOPMENT COOPERATION

Given gender bias and blindness at all levels, what should be the role of international development cooperation in promoting the advancement of rural women?

Development cooperation should provide means for the expression of rural women's interests as well as support for the articulation and implementation of strategies for social, economic, and political empowerment. Diversity among women means that empowerment must begin at the local level—with social learning, organization, and mobilization. To achieve change at the national, regional, or global level, networking, alliances, and exchanges between rural women and their advocates are crucial.

People's organizations, be they women's associations or mixed male-female organizations at local or higher levels, are essential vehicles for mobilizing such empowerment and articulating women's interests and concerns. Through these organizations, strategies and actions may be produced that recognize and challenge gender bias and other interrelated processes that contribute to major problems of our time, including poverty, food insecurity, and environmental degradation.

Precisely this type of networking and alliance building, supported by international development cooperation and the NGO community, has led to the creation of national and international fora focusing on the advancement of women. This includes numerous regional conferences, the three World Conferences on Women that produced the Nairobi Forward-Looking Strategies for the Advancement of Women, and the 1995 Fourth World Conference on Women, which will be held in Beijing in September.

This same networking has led to significant input into other international fora dealing with related issues, such as the environment, in the United Nations Conference on Environment and Development (UNCED) in Rio; human rights, in the World Conference on Human Rights in Vienna; nutrition, in the International Conference on Nutrition in Rome; population, in the International Conference on Population and Development held in Cairo; and social development, in the World Summit for Social Development in Copenhagen.

While the advancement of women is nowhere near what we would like to see, these conferences have raised global awareness. They have led to conventions and agreements that are slowly but steadily producing change at many levels. Bringing rural women's concerns into international fora is one critical step; implementing the platforms for action at national and local levels is the next.

Many women's advocates—including the UN agencies specialized in food and agricultural development, FAO and the International Fund for Agricultural Development (IFAD)—have recognized that rural women, and especially women farmers, have a special and critical role to play in the struggle against hunger, poverty, and environmental deterioration, but they have not been given adequate attention in international fora. In order to ensure a central role for women on development agendas at the national and local levels, as well as the international level, there is a great need to bring together decision makers, rural women, and other women's advocates to identify and negotiate solutions to rural women's most pressing problems.

THE RESPONSIBILITY OF THE UNITED NATIONS SYSTEM

Much has been done since Nairobi to win for rural women the attention they merit, but much more remains to be done. The members of the United Nations system have a responsibility to address the critical areas of concern to women in food and agriculture systems in order to promote women into mainstream programs and projects, and to formulate strategies to:

provide policy advice and technical assistance in areas of their expertise, with a particular consideration of cross-sectoral concerns, including gender;

develop methodologies, tools, and training to assist development planners and practitioners to analyze and integrate socioeconomic, gender, people's participation, and population concerns into projects and programs;

support the gathering, analysis, and dissemination of gender-disaggregated data and statistics in their areas of expertise; and

coordinate with other UN agencies and governmental and nongovernmental organizations on the mainstreaming of gender, people's participation, and population concerns.

THE RESPONSE OF FAO

The FAO Plan of Action for Women in Development responds to the issues of critical concern to rural women that have been raised in a variety of international fora. It also addresses the major objective of the FAO and member nations in relation to agricultural and rural development, notably to stimulate growth with equity while reducing rural poverty and achieving food security. Beyond Beijing, FAO program activities will give priority to six elements that focus on integrating cross-sectoral issues into the mainstream activities of the organization:

1. Training and national capacity building on WID/GID will endeavor to develop the necessary tools and methods, and to organize and participate in various training programs on socio-economic and gender analysis, in order to increase the capacity of the FAO and member nations to take into account the specific concerns of rural women and men in development programs and projects. Special attention will focus on the Socio-Economic and Gender Analysis (SEGA) program being developed and implemented in collaboration with the United Nations Development Programme (UNDP), the ILO, INSTRAW, UNIFEM, and other interested international agencies. Training targets under this element include the staff of the FAO and other international agencies, national counterparts, and the staff in key ministries and NGOs.

2. Policy advice and program and project planning within the organization will emphasize the mainstreaming of gender concerns into the activities of our own technical divisions, a majority of which have now developed individual programs of action for women in development. With special reference to the Platform for Action to be adopted at the Fourth World Conference for Women, the policy and planning advice to member nations will use participatory approaches to formulate national WID strategies; develop or strengthen WID machineries or units capable of designing and implementing programs for rural women; assist in reducing or eliminating legislative, administrative, socioeconomic, and behavioral obstacles to rural women's access to productive resources and services; and promote increasing

women's skills, capacities, and opportunities to participate in decision-making processes affecting their socioeconomic and political status.

3. Home economics, farm households, food, and technology will continue to support the reorientation of the curricula of agricultural and home economic training institutions to meet more effectively the needs of rural households involved in agriculture, fishery, and forestry. The specific activities will take account of the increasing feminization and commercialization of agriculture, as well as food security and sustainability concerns. This element will promote effective service delivery systems to small farm households and strengthened communications systems between communities. Emphasis will be placed on the development and provision of technologies for rural women, on food security issues, and on the expansion of rural employment opportunities for women, including agro-industries and rural services in the formal and informal sectors.

4. Efforts to support and coordinate interagency, national, and NGO WID/GID actions will endeavor to promote the FAO's continued collaboration with other agencies of the UN system as well as governmental and nongovernmental organizations on matters pertaining to the status of rural women. A special concern will be the promotion of women's associations and networking through the exchange of information and technical cooperation among developing countries.

5. Women, environment and sustainable development efforts respond to the recommendations embodied in *Agenda 21* of UNCED, especially chapter 24: "Global Action for Women toward Sustainable and Equitable Development." Under this element, action-oriented research will focus on analyzing the impact of environmental problems and of urban-rural migration and linkages on women's livelihoods and the well-being of their families, including the relationships between population policies and practices and environmental sustainability. Attention will be drawn to rural women's potential and actual management roles in biodiversity and sustainable resource use in such areas

as soil conservation, irrigation and watershed management, shallow waters and coastal resources management, integrated pest management, land use planning, forest conservation, and community forestry.

6. Data collection and studies, communications and information, and WID/GID statistics will support the collection, compilation, analysis, and diffusion of data and statistics disaggregated by gender and the development of indicators on women's participation in agriculture and related fields; the relationship between rural women's status and demographic dynamics; the constraints to the participatory involvement of rural women in development activities; and the roles and contributions of rural women in achieving poverty reduction, building food security, and attaining sustainable development. This element will also promote national capacity in the formulation and implementation of communication policies and programs to provide information about, and motivation to, rural women.

An Investment in the Future

Rural women should be recognized as skillful managers and architects of food security and included in the making of large-scale decisions that relate to biodiversity and the management of general resources for millions of households throughout the world. An investment in improving their situation is an investment in the future. This is one of the major messages the FAO is bringing to the Beijing conference—and beyond. The FAO recognizes that putting rural women's issues at the center of the international development agenda is essential for economic growth and development. But more important, it is the crucial factor required to ensure food security, poverty eradication, and environmental sustainability.

—Director, Division of Women and People's Participation in Development, Sustainable Development Department, FAO

3

CSPD/WOM

*T*HE IMPACT OF INFORMATION TECHNOLOGY ON WOMEN AS PARTNERS IN THE DEVELOPMENT PROCESS AND IN THE UN SYSTEM

Sylvia Perry

The last twenty years have seen remarkable developments in information technology. The fundamental microelectronics technologies underlying information computing and communication technologies are still changing very rapidly and at a pace that is expected to continue for the foreseeable future, bringing even more exciting opportunities.

However, Dr. John Taylor, the director of Hewlett-Packard Laboratories, Europe, one of the world's major computer research laboratories and production companies, reports that the corresponding software and systems technologies needed to make effective use of the available hardware are proceeding much more slowly. Huge investments are needed to build pervasive communications infrastructures and convert paper-based information into commonly accessible electronic form. This means that the absorption of the information technologies into the fabric of our social, economic, and domestic life is decades behind the innovations in hardware. Nevertheless, the technological possibilities are enormous, and despite any delay in funding the immense investment and production plant costs, electronics is forecast to be the largest industry in the world by

the end of the century and expected to account for 10 percent of the world's gross domestic product.

Just now there is a great surge of interest in developments in information technology, particularly the ability to convert any medium into digital form. Global digital "intelligent networks" for telecommunications, electronic mail, multimedia conferencing, CD-ROM and other massive storage features, and voice-activated and speech-translation appliances are revolutionizing communications and making people think differently about computers. One only has to think of the fax machine, which not long ago was in restricted use but is now not only a basic item of equipment in every office but is becoming as commonplace in homes as microwaves, coffeepots, or any other item of electronic domestic apparatus. The emergence over the past few years of the Internet, with its estimated ten to fifteen million users around the world, has captured the imagination and created a web of information linkages. Suddenly, we have the "information superhighway"—not really a completed motor way or autobahn, but an interesting road to travel along with a worthwhile destination to reach and one that is wide open for women drivers.

The potential is there for women to grasp, to be full partners and leaders in the information industries that the current developments make possible. Now that we have very small digital processing, display, and communications systems that fit equally well into both home and office, the prospects are available for women to develop more flexible working patterns and their own high-profile businesses.

In the early 1960s home working by professionals in a computer company began in Britain. F International was created by Steve Shirley, a woman professional who saw the business opportunity coupled with the demand for home working because of family responsibilities by women trained in computer skills. Many employers seized upon the opportunity to move secretarial routine work out of house, not in pursuit of a more innovative working style, but simply as a means of cutting overhead costs.

The difference between now and then is that women are not just doing data inputting and word processing at home as a means to earn income while caring for children or elders. Increasingly, women are using sophisticated technology appliances as tools to facilitate more responsible and creative roles and generally enhance their

quality of life. Isolation is the danger that arises from working at home, but as technology becomes more pervasive, women will discover ways to form networks and strong support groups. They will be able to control their working time and manage quality time for their business and social contacts and networking.

Take as a positive example the Scandinavian cabinet minister who spends one half of her working week looking after her small son at her home, hundreds of miles from her parliamentary office, maintaining daily contact with her advisers, staff, and others by means of image teleconferences. The same independence from location permits journalists and freelance magazine writers to download their copy from home or elsewhere. Men who can work independently of their business address have the opportunity to share family responsibilities more equitably.

Attitudes toward information technology are changing, but women still need to be educated to use it as a management and information tool (as men do) and not regard it as just a replacement for typewriters or pen and ink. They need to go beyond the use of a PC for word processing only. Accounting, investment planning and appraisal, business analysis and results monitoring, and technical and financial progress reporting are all available software programs they can and should access. The packages UNIDO offers with its UNIDO Computer Module for Feasibility Analysis and Reporting (COMFAR) software are excellent examples of user-friendly business-oriented material.

Information technology will help women communicate and develop only if they understand its full capabilities. Whether working for others or themselves, they need to be equipped to use it to its full potential. Investment in equipment and software will not deliver the promised benefits without a corresponding investment in training. Furthermore, the training must start early with a guarantee of equality of access for girls and boys in educational curricula and informal learning, with an emphasis on technical knowledge being put ahead of user skills.

Adult training courses are an excellent vehicle for women returners to sharpen their skills, adapt to new cultures, and develop problem-solving techniques. Distant learning can achieve results if work stations are made available and if a tutor is easily approachable for advice and support. The European Community's Trans European

Education Network seeks to provide, with the help and cooperation of the network operators, an infrastructure to support the transfer of learning materials, provide access to databases, and enable people to communicate for the purposes of enhancing skills and knowledge. Software now in multimedia makes possible a new audiovisual world and the networks to enable a learner to connect with any kind of recorded information irrespective of the part of the world in which it is stored.

Women, by acquiring knowledge of information technology, become empowered. They develop confidence and a desire to use their new skills. With hope, their new confidence will inspire them to seek a higher-level or a more ambitious position when they go for their next job or perhaps use their newfound skills in a public role. Certainly, if they move up the management ladder, new skills and improved access to information will make them better equipped to make the decisions required of more senior roles.

This scenario appears to be very much a Western or developed-country model, where technological resources are part of everyday life. Providing there is some access to power and materials, however, any person may travel electronically around the world, with distance, location, and time delays becoming irrelevent.

The cost and means are, of course, an enormous barrier to obtaining the link into such a worldwide communication system; this is particularly true for women. There is a need for a concerted program to build women-friendly networks, modules of learning material, and information strategies that could be developed by a partnership between women's organizations, corporate sponsors, and the UN agencies. Economic aid is as vitally needed for information technology as it is for any other material resources in developing countries—not only the traditional developing countries but also the former Eastern bloc. Women in those countries are desperately trying to keep up their scientific and technological knowledge while urgently attempting to learn new skills applicable to market economies.

There are already in existence some networks that can assist with disseminating knowledge. In the United States a company that provides technical assistance to developing countries has launched the first in a series of twenty-four low earth-orbiting satellites to which anyone can connect at low cost. The implication of this idea could transform the availability of medical, business, and technical

information. Whether UNESCO could examine similar strategies in partership with women's NGOs and relative financial backers is a point that needs to be taken further. The International Federation of Business Professional Women (IFBPW) has a mandate, adopted with great enthusiasm at our last congress in Nagoya, Japan, to develop this concept in close cooperation with UNESCO, UNIDO, and other relevant UN agencies.

Of course we must endeavor to use existing information networks, one need not waste valuable time in reinventing the wheel. The Eures computer network, connecting job seekers across Europe with employers by access to the 350 terminals in employment offices in the EC member states, is an example of technology cutting down the search time for both employers and potential employees. In a similar way the Résumé Database System, a university-linked system that is mailed to employers on a computer disk, helps companies identify promising graduates, thus simplifying the hiring process in a complex job market.

This statement on women's involvement with information technology cannot ignore the "downside" of the electronics world. In the electronics technology manufacturing industry, despite a large measure of automation, the majority of manual jobs are carried out by women. Unfortunately, many of these jobs involve routine tasks for low wages and poor working conditions, with little prospect of progressing to a more skilled area. The women's movement must fight for the improvement of these workers' pay and conditions and for the provision of career structures that lead to greater job satisfaction or managerial roles. Trade agreements and cutthroat competitive markets keep such jobs depressed in status and remuneration, As long as the profit margin remains the driving force, innovation and job enhancement will not feature on a manufacturer's agenda.

Yet women can work together to improve their status and conditions. The Fourth World Conference on Women in Beijing in September 1995, with its aim to establish a Global Platform for Women; offers the chance to collectively lobby and influence governments and other international organizations, including the multinational corporations that "govern" economies and markets.

The UN system has become the world focus for women's organizations to work together. UN agencies are tackling gender in development issues and making resources available to help educate

and train women through a variety of development projects. Women's organizations have participated in and supported these initiatives.

Women NGOs have been preparing for the Bejing conference with the assistance of information technology. The NGOs have used computer technology and other technical aids to sharpen their representation and lobbying techniques when participating as observers and lobbyists at all the regional conferences, the world population and development conference, and the world social summit, culminating in the March 1995 CSW session.

It was a major achievement to incorporate the views of the fourteen-hundred women present at the two-day consultation preceding the CSW, to make the necessary amendments to the draft Platform of Action documents, and to have this printed, published, and distributed to all the government delegations within seventy-two hours. This accomplishment presented a clear message to the CSW delegated and a strong statement for the ongoing lobbying activities. Dissemination of information, networking, and bonding on issues were all facilitated by the briefing sheets that information technology services provided speedily. A proper business center, with Apple and Hewlett Packard equipment, photocopiers, computers with software in all available languages, and media and E-mail facilities, is due to be provided for NGOs in Beijing. With that capacity, allied to their technical expertise and skills, women attending the Fourth World Conference for Women will no doubt make a significant contribution not only to the deliberations but also to a better future for all women.

—Regional Coordinator Europe, IFBPW

4

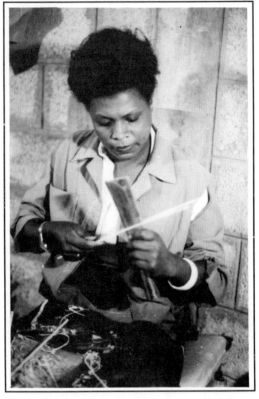

CSPD/WOM

*I*MPROVING OF THE STATUS OF WOMEN IN THE UN SYSTEM

Reginald van Raalte

WOMEN IN THE UN SYSTEM

Although the United Nations has set numerical targets for the hiring and promotion of women, statistics show slow progress in almost all areas. According to a Joint Inspection Unit (JIU) report published in January 1994, "The major obstacles to women's advancement—in recruitment, career development, training, work/family related issues, and grievance redress systems—have been much talked about, but scarcely reduced." Despite all the efforts made so far by the UN common system, senior level posts, especially, have remained resistant to women's entry. A fuller understanding of the barriers that have limited professional women's access to senior level management is thus needed if those barriers are to be lowered and eventually eliminated.

Efforts to promote women to the senior level have progressed slowly but visibly. An important distinction must be made between entry into the senior level and "upward mobility" within a management level. We should not be too impressed with the thin trickle of extraordinary women, operating under exceptional circumstances in each organization, who have succeeded in breaking through the glass ceiling and, in a very limited number of cases, assumed senior-level positions. Further efforts are still needed to ensure upward mobility for those women presently serving at P-5 level so that they will assume senior management-level positions (D-1 and above). The

United Nations common system must view women's assignment at senior and management-level as a recognition for their excellent contribution rather than the result of the legislated mandates of their governing bodies.

The successful performance of women at the management level should offer the UN system an opportunity to use women's talents to promote the goals of the organizations. Too many highly capable women are promoted to senior levels and then not fully utilized by their organization or agency.

The UN organizations must design effective policies that will ensure the implementation of their legislative mandates by their governing bodies. These policies have to be capable of both increasing the number of women in the system and remedying the current inequality at senior and management levels. In particular, the UN common system must provide professional women the experience and the leadership ability needed for senior-level and management positions.

THE CASE OF UNIDO

UNIDO attaches great importance to improving the status of women within its secretariat and throughout the UN common system. The UNIDO General Conference in 1993 as well as its Industrial Development Board in 1991 called for efforts to increase the number of women in the secretariat, particularly at the senior and decision-making levels, and to achieve, to the extent possible and within existing resources, targets for the overall representation in geographical posts by 1993 and 1995 of 25 and 30 percent respectively.

The Industrial Development Board and the General Conference in 1987 requested the director-general to designate a high-level coordinator for the improvement of the status of women in the secretariat within the existing resource allocation for personnel services. The coordinator, who was appointed in 1988, has outlined a series of measures to be taken to improve the professional status of women in the secretariat.

In 1991 the Industrial Development Board requested the director-general to reinforce the existing machinery on the status of women in order to increase the participation of women in the secretariat, particularly at senior levels, and to ensure steady improvement in that respect. In December 1991 the Joint Advisory Committee (JAC)

Sub-Committee on the Status of Women in the Secretariat was reinforced to assist the high-level coordinator in implementing the targets set by the policy-making organs of the organization.

UNIDO's current staff structure is still weak in terms of the overall representation of women at the professional level in the secretariat. The organization has continued to experience difficulties in identifying female candidates, particularly from underrepresented developing countries, despite the continuous efforts undertaken by the organization to identify candidates through its field offices, group training and fellowship programs and repeated appeals to member states at various forums. Currently, 23.3 percent of the professional staff in the organization are women. In light of UNIDO's highly technical environment, it can be considered a success that we have been able to attract a good number of female engineers and other technical specialists, in addition to economists and administrators, bringing female representation close to 25 percent of all geographical posts. The organization will make efforts to meet the 30 percent target by 1995.

The organization is doing its utmost to increase the roster of female applicants. In this context, UNIDO will arrange for a stand at the fourth World Conference for Women in Beijing with a staff member from personnel services assigned to advise on UNIDO's activities and to solicit applications. On a different front, the organization will intensify the briefings provided to UNIDO country directors, junior professional officers, and chief technical advisers to assist in these efforts. UNIDO also intends to write to selected universities in an effort to identify female applicants.

The organization took other measures to advance the career of women in service. During the 1994 promotion review, the director-general applied special procedures for calculating the seniority of female professional staff members by averaging the service at two levels in determining their seniority in grade. This has caused the proportion of women at the senior professional level to rise significantly, from 7.1 percent in 1993 to the current level of 13.4 percent, which is getting closer to the target of 15 percent for 1995.

There is a very encouraging trend in the proportion of women from the lower to the middle professional grades. For example, in 1993 only 11.2 percent of all professional women were at the P-5 level or above. That propotion had increased to 21.1 percent by April 1995.

In an effort to enhance the experience of currently serving female staff members, the organization has cooperated with the United Nations and other specialized agencies in releasing these staff members on peacekeeping assignments of relatively long duration. We hope that these assignments will broaden their experience and exposure to development issues. It is expected that through these assignments they will be able to diversify their experience and acquire new skills. A special roster of women interested in peacekeeping and other field assignments will be established to further their mobility and widen their experience in different capacities.

UNIDO has no legal hindrance to spouse employment, and UNIDO's scheme of flexible working hours was designed to resolve some of the work / family issues currently under review. In the same vein, we have a very flexible approach to granting extended leave of absence to women in case of childbirth. We are encouraging staff members, men and women alike, to undergo additional training to enhance their career prospects. This includes a policy of granting liberal leave for training purposes, including leave on partial pay or full pay when appropriate.

The director-general has recently issued a policy statement on the importance of managerial accountability in ensuring that the status of women is under constant review. The statement reminds staff of established targets for the representation of women at the professional and senior levels. The director-general also asked the subcommittee to study further the current status of women in the organization and to make specific recommendations for the further advancement of women in order to alleviate the major shortcomings. The new performance appraisal system that is being designed is intended to explore the possibility of evaluating managers' contributions in the achievement of gender and geographical balance in the secretariat.

UNIDO is planning to recruit a senior consultant to review and design measures for enhancing gender balance within the organization. The consultant is also expected to formulate specific recommendations for alleviating major obstacles to women's participation at all levels in the organization.

Personnel services intends to conduct interviews with all professional female staff members in the course of the next few months to exchange views on areas of expertise and interest in terms of career

development. UNIDO will also intensify briefings for country directors and junior professional officers on steps that have to be taken to identify women candidates from underrepresented countries.

The organization will continue to organize training courses under its management development program in the areas of cross-cultural team building, intercultural/interpersonal skills development, and leadership styles. In addition, workshops for senior managers will be organized in gender awareness and cultural diversity. The number of women participants in various modules of the management development program has increased significantly in the past year. For example, in 1994 the proportion of women participants in various modules of the management development program ranged from 32 to 58 percent. UNIDO will explore the possibility of organizing specific workshops for the members of the Professional Women's Forum in assertiveness, networking, management of time, and leadership styles, among others.

RECOMMENDATIONS FOR THE UNITED NATIONS COMMON SYSTEM

1. Make concerted efforts to implement existing policies fully as well as to develop new initiatives to increase the participation of women at the senior level.

2. To increase the presence of professional women in senior management positions, the United Nations common system must design executive development program and ensure to the extent possible that 50 percent of those enrolled be women. This will help the organization to increase the percentage of women at senior and management levels.

3. Promote and intensify gender-awareness issues in order to hold senior managers more accountable in the achievement of gender equality goals.

4. Design career-planning programs for junior professional women to ensure that they will have the opportunity to obtain the experience required to reach senior-level management. This can be done through training and development programs.

5. Utilize succession planning for professional women to help identify potential managers in advance for positions at the P-5 level and above.

6. Develop new approaches to free women from remaining trapped at one level, for example, through rotating assignments within and outside the organizations, including field assignments and peacekeeping assignments.

7. Conduct a survey of female applicants who declined job offers with the UN system. Why do they decline?

8. Create an interagency exchange training program.

9. Establish long- or short-range recruitment objectives according to the priorities of the organization. Based on the targets, contact professional organizations and well-known institutions to identify candidates. Build the pool of women candidates in all priority sectors.

10. Based on the organization's targets, identify female candidates to fill all vacant posts.

—Managing Director, UNIDO

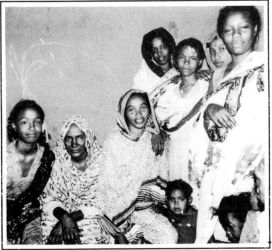

A group of village women engaged in backyard gardening (*gibraka*), and poultry keeping activities within FAO's "Income Project for Rural Women," Sudan.

\mathcal{T}HE WOMAN ENTREPRENEUR

*The Challenges in an Age of
Globalization of Enterprises*

Tamara Martinez

All too often we continue to read in reports from diverse cultures around the world of the resentment, at worst, or lack of recognition, at best, of a woman's achievements when these surpass her partner's or she becomes economically independent. How much this has to do with tradition (i.e., society's perception of the man's own place and achievements) and upbringing and how much with men's own competitiveness, their need to dominate and feel superior, are factors that both men and women have to reconcile with women's own need to expand their abilities beyond that of traditional roles as wives and mothers. Ultimately, recognition can come about only when each learns to put aside envy and respect the other's abilities and qualities.

One of the greatest obstacles to women's achieving parity of status in managerial and decision-making positions is that of working hours. Historically, businesses have been run by men, who established working hours that did not take into account women's or the family's needs. Today, women and children still have to adapt to the business world's schedules. Managing child care is essential if we are to give children an adequate start in life. Care for the disabled and elderly must also be addressed seriously when planning for the future. Businesses—and governments—should be adapting to people, not the other way around.

Unemployment, at an all-time high in most countries, would seemingly lead to a shorter working day in order to share jobs more

widely. Instead, in most companies, in order to reduce the most costly factor in a company's budget—salaries—shed jobs with the result that the remaining workers are obliged to combine their job with that of a former colleague. This does not always bring greater financial reward, but does place greater stress on the individual, who must work longer hours to complete tasks. Women are natural victims, as a woman's family commitments, almost always greater than her partner's, may well oblige her to downgrade her job in order to keep on working and balance her family responsibilities. It is when a woman becomes an entrepreneur that she can achieve greater control over her time and the way she wishes to allocate it.

When we talk of globalization of enterprises, we often mean the development of similar methods of doing business, the harmonization of systems, and the assimilation of smaller fry by the multinational and transnational conglomerates. This paper, however, looks at a global, concerted effort aimed at developing small and medium enterprises especially with women in mind.

Three qualities that women bring to business are their patience, their sense of responsibility, and their multidirectional approach to everything they do, as opposed to the more single-minded and impatient approach of men. The advantage men have in being able to focus more strongly and single-mindedly on one item at a time can bring greater concentration to bear on the resolution of a problem or in achieving an objective. All this can be counterbalanced, however, by their impatience. The woman's ability to handle diverse tasks at the same time is reinforced by her determination and attention to detail, as well as her strong sense of responsibility. This is not to say that men do not possess the latter quality, but a man is often able to walk away from a responsibility more easily than a woman can, which means that in an ailing business a woman is more likely to seek to resolve the problems and may be more considerate to debtors, while a man may be more likely to decide to call it a day and seek bankruptcy as a solution, with less consideration to debtors.

This sense of responsibility in women has been recognized already by many lending institutions, which have noted a marked increase in the repayment of loans when lending to women in developing countries, even in microenterprise situations in the poorest areas. Indeed, greater consistency in developing micro, small, and medium

enterprises has been observed precisely because women have a greater sense of responsibility to their families, in the first instance, and to their communities, in the second. We have known for some time, for example, of instances where men were given seeds to sow and, having sold their crops at market, went on to use all or most of the money on drink and women. But when women are given the same facilities and have sold the crops, they put aside money for the purchase of more seeds, and food for their family until the next crop, and if there is anything left over, it may well go to the husbands who spend it on drink and women, if they have enough.

The first consideration should always be for a nation to develop a sound agricultural policy; this guarantees its independence and prosperity, as it is able to feed its own people. These basic needs should be well established before moving on to production for trade, which is, in any case, a natural progression toward an industrial economy. Most countries can create such a base. Globalization then becomes a viable economic exchange between independent nations. Over the ages, communities, in general, endeavored to produce what they needed in order to survive. It seemed the natural thing to do. Nations in Europe, for example, developed agricultural systems over centuries according to need, and this created a sound economic base on which to build future economies. What has been happening in many developing countries is that outside market forces have been allowed to dictate over several decades and have encouraged the production of cash crops to sell abroad, at prices over which they have had little influence in setting, using up valuable food-producing land. These countries have then been obliged to purchase provisions from outside, using precious currency earned through their cash crops, instead of investing in their future. When the small farmers, denied the option of reverting to food production, finally abandoned land that could not feed them, that land often became desert: a futility of efforts leading nowhere. Often it has been the women in rural areas who, with the odds stacked against them, have succeeded not only in generating a subsistence level of food for their own consumption but also in supplying something to urban areas.

There is an urgent need to multiply our present efforts, as too many countries are still striving without significant gain to adopt new technologies when their primary structures are not well developed,

and much harm has been done by misplaced aid. Bridges, railways, and dams are necessary, but they will serve the country only if they can be used; people who have no produce and no money, will be unable to use the highways and transport facilities and will remain in their villages. Infrastructures, though necessary for a country, should be in keeping with economic progress and not become yet another loan to be repaid. Expensive projects may benefit engineering firms in developed countries but place greater debt burdens on the recipients. The backbone of any economy is its entrepreneurs—the farmer, the artisan, the builder, the small shopkeeper—and these are the ones who should be receiving their fair share of the billions of dollars of misplaced aid. Helping individuals, families, and communities to become self-sufficient must be a priority and will be far less costly if we give them the tools.

As entrepreneurs, women seek economic independence, access to decision-making positions, and freedom to make decisions about their own future. Women who become entrepreneurs can decide the hours they wish to work and adapt these to suit their and their families' needs. These are advantages male entrepreneurs also enjoy, but in a woman's case they give her that unique independence she does not otherwise enjoy when she has to enter a male hierarchy. The challenges are still there, as a woman has to trade within a largely male-dominated market, but at least she has greater direct control over her business and its growth.

In a recent IFBPW survey of women entrepreneurs among its membership in both developing and developed countries, the most important thing respondents wanted was "effective networking": networking to help them exchange information, maintain links, and develop knowledge. Men have long enjoyed patronage through the "old boy network," which has excluded women and continues to do so. Although women may well find it useful through networking to locate opportunities in job searches or business opportunities, they do not see it as the old system of favoritism along the lines of "I knew your father," but rather as a support mechanism. Balancing career and family was also high on their list of priorities, as were marketing skills.

The primary objective of the IFBPW's global effort to assist women entrepeneurs will be to establish and develop projects with ongoing training. These projects will be both sustaining and able to be replicated in adjacent villages or localities. This propagation of projects, like a

field of mushrooms, will create a widespread economic base at the grassroots level. The emphasis will be on flexibility and speed. To target areas effectively and to avoid wasting time, project proposals should tap the valuable sources of information built up over the years by UNIDO, FAO, and other organizations.

Suggested action is outlined in the following section.

FACILITATION AND EMPOWERMENT

1. Create small task forces of two or three persons to go on field trips to selected areas where they will identify needs, abilities, and facilities and prepare feasibility studies and budget proposals.

2. Set up cooperatives and explain their basic function. The cooperative system envisaged is of a loose structure, more in the nature of a facilitating unit to provide the necessary support, initial and ongoing training, financial knowhow, and channeling of financial help.

This structure should be strong enough to hold the group of businesses together during its earlier stages, but flexible enough to allow individual businesses to maintain their independence. This is important, as at various stages some participants who may wish to opt out if they find they can develop their businesses at a faster rate outside the group, or if they have personal or family reasons for leaving. It is vital that they should be able to do so, if they wish, but without damaging the interests of the ongoing group. Some of the participants will become trainers themselves in various areas, thereby creating their own service industries.

Cooperatives in these cases can often be most effective where they bring in the family unit and immediate community. For example, the women involved in a particular project have children who need to be looked after, so other women, husbands, and elders can be engaged to look after them. Recompense can be in kind or money, according to what is produced. But all are considered a part of the project whatever role they play. It is a partnership. This avoids the marginalization of certain groups within a community, as so often happens, gives people a sense of worth, and protects the family unit.

3. Establish training programs. At various stages of development, these small cooperatives require more advanced training which may be obtained from various agencies. For example, the Programme for Development Cooperation (PRODEC), an independent center that offers training though seminars and diploma courses, could offer tailor-made programs to match the emerging needs of the cooperatives, microenterprises, and small and medium enterprises (SME). A cost-effective system is the use of continuous improvement technology, which is highly effective both in smaller and larger enterprises. UNIDO also offers a number of programs. Marketing, CBI, a government-funded agency based in the Netherlands, offers both practical help in marketing and trade for developing countries as well as training opportunities.

Women in emerging economies have a pressing need for training in business systems, basic accounting, marketing, and computer and other skill development, but often, their most urgent need is to learn to read and write. We well know how often girls and women in developing countries are neglected when it comes to education, and much has been written on the subject. It is through such agencies as UNESCO, UNIDO, and nongovernmental organizations like the IFBPW that training programs are being set up around the world.

4. Set up microenterprises that may or may not be incorporated into a cooperative. Training programs are also essential in this area.

5. A primary health care program should always be attached to any project and can be developed as projects move forward.

More than one cooperative may be set up at a time where there is a diversity of projects and as the microenterprises grow. In rural areas the emphasis should be on developing food production to feed the community and, secondarily, for trade. Where there exist part-time women traders, subsistence farmers, or any cottage industry, these can be incorporated into the cooperative to help them channel their produce and efforts. In towns, where the emphasis might well be more on manufacture, arts and crafts, food processing, and the likes, these cooperatives should be put in touch with projects in rural areas so that trade can develop between groups. A natural empathy should be

encouraged between these embryonic businesses to strengthen and support their development and create a feeling of solidarity among the groups. Networking has been shown to provide many benefits.

Women, who tend to have a more naturally developed empathy with nature, should be made aware of the effects of any project on their environment and taught to monitor these effects to enhance their surroundings and provide a safe and healthy habitat for their community.

There is a wide diversity of skills already in existence but so few ways to channel them into creative and income-producing businesses. Women can develop many nontraditional occupations. Our members in Argentina developed their HANOMI projects and proved that point by developing cooperatives in some of the poorest areas, often in trades not usually practiced by women. They learned woodworking, plumbing, and gas fitting, for example, an unheard-of idea at the time, but successfully developed within their cooperative. Small production units have been set up, where viable, and training programs established as needs arise.

We know that many agencies and NGOs are constrained in the level of help they are allowed to bring, as governments are often reluctant to allow change that may erode their power. Local authorities can be valuable allies and should, wherever possible, be used. In a village in Baja California Sur, in Mexico, IFBPW developed a nursing school project, under our International Project Five-O series in conjunction with four other international women's organizations. The full support of the local and state authorities allowed the project to progress at a faster rate than would otherwise have been possible. The emphasis must be on assuming a sense of urgency at all times, an anxious expectation of success.

Among its publications, UNIDO has published a training manual on gender related issues, with training modules and case studies, that can save time and help avoid repeating mistakes when developing new projects. For some years IFBPW and UNIDO have collaborated on seminars for members in Latin America, Asia and the Pacific, and Africa that have proved beneficial; we now have yet another initiative on which to work together. Back in 1986 UNIDO recognized that "a large proportion of UNIDO's existing programmes and projects could have a more positive impact on the integration of women if the

questions of concern to women were taken systematically into account during project planning and design." Although the paper went on to say that projects that focus on women should be the exception rather than the rule, targeting women in these startup programs would enable them to bring their influence to bear on a more women-friendly environment.

FINANCE FACILITATION

To succeed in such a global enterprise requires a common vision and determination as well as the harnessing of dedicated workers and the attraction of funds from governments, agencies, banks, and private enterprises. Instead of millions being handed out for grandiose projects, these can be channeled directly to identifiable and workable projects. Women's World Banking (WWB) was created specifically to assist women in setting up in SME; the IFAD is another important funding agency that already provides much aid. We also need more of the brave intiatives from men such as the bank in one Asian country that decided it was good business to make loans to microenterprises set up by women. Yet, with all this help, we are progressing too slowly, and this sense of urgency must be developed through the UN, its agencies, and outside agencies using machineries already in place, but collaborating more with each other and with NGOs, such as the IFBPW, which have thousands of grassroots members who can be mobilized if only the resources are made available.

We know that money is one form of power, and women in too many countries are still prevented from owning their own assets and bank accounts or having access to credit and rights to inheritance, all means of achieving economic independence. These practices have nothing to do with tradition, but are calculated to ensure control in male-dominated societies. There can be no justification for such behavior.

Accountability and evaluation are other key features so sadly lacking in much of the massive aid that has sunk without trace. All projects should have built into their programs a continuous assessment system and a time frame within which they will become self-funding. Giving people the tools to become economically independent is the ultimate objective for each project. Past experience has shown

that the level of funding required is very low compared to the rewards. By targeting women, we will aid their full integration into society through their work and their social life and ensure their place in decision making roles.

Several women's organizations could become involved in the propagation of these projects in a concerted move forward, rather than the individual efforts that, however laudable and well conceived, have required many years' effort have little lasting effect on poverty and hardship. UNIFEM's expertise could be used in the elaboration of the feasibility and budgetary studies. IFBPW has a membership in over one hundred countries, but like its sister counterparts, it does not have the resources to develop such an undertaking unilaterally. However, if we mobilize forces and enlist the help of UNIDO, which is ideally placed and structured, we can develop a dynamic but flexible force. Today, when we know that transnational corporations have for some time been moving away from developing countries,where they sought low-cost labor and resources, to seek higher-level skills through local enterprises in developed countries, it becomes even more imperative to seek to fill that void.

The macroeconomics of our age have not got our economies right yet, as we know only too well, and while government leaders hold their G-7 talks and hold sway over millions who have no say in these matters, many women wish to take hold of our destiny and become a viable force in our economies. There is enough expertise and enough willing hands to make such a proposal a reality. This is the big dream for microeconomics. Let us mobilize and take this hope forward, in true partnership, in our search for those elusive goals of equality, development, and peace.

—Director, International Federation of
Business and Professional Women

Photo by Nancy Falcon-Castro.

*W*OMEN IN THE GLOBAL LABOR MARKET
Empowerment and Enabling Environment for Progress

Eugenia Date-Bah

Considerable changes have occurred in the labor market during the past decade as a result of a number of global, regional, and national developments. Of significance among the developments are technological transformation; the globalization of markets, trade, and production; investment flows; economic reforms such as liberalization, the transition to a market economy, and more flexible labor arrangements; the restructuring of work organizations; and demographic changes. All of these developments have had repercussions, both positive and negative, and have created challenges in the quantity and quality of employment. Examining these changes and how women have fared in them can provide us with some indication of whether the current labor market has contributed to women's empowerment and also whether it has provided an enabling environment for women's employment and progress.

This paper (1) briefly highlights some of the recent changes in the labor market and the kind of environment provided for women's participation; (2) analyzes how women have fared in this environment; (3) examines the required strategy for action; and (4) indicates what role the UN system can play in relation to this strategy.

SOME FEATURES OF THE CURRENT LABOR MARKET

The curret labor market is characterized by several trends. Among them are the following:

- Increasing interdependence and internationalization of labor markets, with developments in globalization, communication, and information technology.

- Retrenchments and cutbacks in public spending and the privatization of public-sector enterprises and services, with an adverse impact on employment opportunities.

- Relocation of some operations of multinationals and the growth of export-processing zones in a number of developing countries to take advantage of the cheap labor, mainly female, available there.

- Sectoral shifts, such as growth in service sector, with considerable employment opportunities for women and the decline in some areas of manufacturing.

- Growth in part-time, temporary, home-based, casual, and other precarious forms of work.

- Changes in the formal sector, including the emergence of the lean organization in response to exigencies of competition and global recession, which has contributed to stagnation and even loss of formal-sector jobs;

- Growing "informalization" of employment patterns not just in developing but also (to some extent) in developed countries, with the problem of overcrowding of the informal sector in many developing countries.

- Blurring of formal and informal sectors with deregulation.

- Considerable expansion in the labor supply. About 43 million new job seekers annually are reported to be in the labor market, with high levels of unemployment and underemployment as a result.

These labor market trends have created employment opportunities for women but also risks and challenges for them and for the promotion of gender equality for women in the world of work.

How Have Women Fared under These Labor Market Changes?

The available statistics show a dramatic rise in women's participation in paid employment in almost all regions of the world. In 1990 about 854 million women were in the labor force, and this number is reported to be growing annually. This new trend has been referred to as "the feminization of the labor market." Women in most parts of the world are no longer a "reserve" labor force or "secondary workers" but are fully committed workers who remain inside the labor force in some form of employment throughout their working lives. The participation of women in formal-sector employment has risen from 37 to 40 percent between 1970 and 1990. In the Organization for Economic Cooperation and Development (OECD) countries, there were 169.4 million women in the labor force in 1992, thirty-three million more than in 1980. In some countries, near parity with men in economic participation has even been reported. Women's economic participation rate is growing at 2 percent per annum, which is twice that of men. In Central and Eastern Europe, despite the economic restructuring in the wake of the transition to market economies, female labor force participation, according to ILO surveys, has remained strong. Women have, however, lost some of the state-funded social infrastructural and support facilities and have also not been able to fully tap the emerging entrepreneurial opportunities.

In Latin America and the Caribbean, women's position in the labor force rose from 24 to 29 percent between, 1970 and 1990. Increases have also occurred in Asia. In East and Southeast Asia, for example, women—who have been absorbed in the growing export-processing zones—now constitute as much as 80 percent of the work force in this sector. Another significant feature of the Asian labor market is the growing numbers of women in international migration. In Africa, official statistics indicate a decline in female activity rate, but unofficial data show very high participation rates especially in the rural and urban informal sectors, despite the persistent underreporting of women's work.

This unprecedented trend is closely linked to the positive developments in women's education and vocational and technical training, as well as to basic economic necessity. In the wake of recession and

falling real household incomes, two incomes have become a basic necessity for the survival of many households. Another contributory factor is the increased availability in the labor market of jobs—such as service-sector employment, part-time, temporary, home-based, and other precarious forms of work—for which women are readily accepted or even preferred to men. Also of significance is the growing public sensitivity and acceptance of working by women. The "glass ceiling" or "concrete wall" has been penetrated in some instances by the gradual but steady increase in the number of women now occupying traditionally male occupations and managerial and decision-making positions.

A close examination of the above positive trends reveals that the rise in women's participation in the labor market has not been matched by a similar level of progress in the quality of women's work, including their working conditions. Gender inequality in pay and both horizontal and vertical job segregation continue to be universal features of the labor. Recent data from four developed countries, for example, indicate that almost half of the labor force is in gender-dominated occupations, where either women or men constitute 80 percent of the participants. Although pay equity measures have been adopted in some areas and several countries have reported reductions in male and female wage differentials, the ratio of female to male earnings has not risen substantially. Even when adjustments are made for productivity-related and human capital factors that determine wages, a substantial gender pay gap remains, which reflects the persisting discrimination against women workers in the labor market. Women continue to be concentrated in a narrow range of occupations, skills, and sectors, which continue to correspond to the roles socially assigned to them in the larger society. In some areas, retrenchments in public-sector employment, which traditionally has been a sector favorable to women, have contributed to the overcrowding of the informal sector, with reduced incomes and greater competition between its participants. The rapidly growing numbers of part-time, temporary, and other insecure forms of employment that have occurred in some regions are also characterized by weak social protection and limited job security and career prospects for their participants, who are mainly women. Thus, while the growth of these types of work has provided increased employment

opportunities for women, it has also contributed to the vulnerability of women and widened the gender differential in the labor market. While the export-processing zones may be creating employment opportunities for women, they also tend to exploit their workers, for example, by not allowing freedom of association and collective bargaining, and also by means of their limited observance of occupational health and safety standards.

Many women still face inequalities with men in preparation for entry into the labor market in terms of level and type of education and training, skill diversification, skill flexibility, and access to essential productive resources. The persisting unequal sexual division of labor in the sharing of family responsibilities and the inadequacy of measures to reconcile reproductive and productive activities continue to penalize women in their employment and career opportunities. A number of such vulnerable groups as migrants, home-based workers, and urban-, informal-, and rural-sector workers continue to be outside the purview of existing labor legislation and do not have adequate social security coverage. Furthermore, the considerable exploitation of female international migrants working as housemaids and "entertainers" has been well documented in recent ILO and other studies.

Despite the significant increase in women's economic participation, the statistics also show that women still outnumber men in unemployment and underemployment. In addition, poverty among women has been rising. There is, furthermore, the fear that the current revolution in information technology could make obsolete some traditional "female" occupations in favor of a core group of highly skilled, comprehensively trained, and versatile workers, who so far have tended to be men. While most states now have maternity provisions, such provisions continue to be used by employers to discriminate against the employment of women, especially in countries where the cost of such protection is borne solely by employers.

In relation to women, therefore, one could sum up the current developments in the labor market as having created not only opportunities but also risks and tremendous challenges. At the same time, they have not succeeded in eliminating the obstacles and inequalities that women already faced. They point to the continued relevance of

international labor standards, especially International Labour Convention No. 100 on Equal Remuneration, No. 111 on Discrimination (Employment and Occupation), and No. 156 on Workers with Family Responsibilities.

WHAT IS THE REQUIRED STRATEGY FOR ACTION?

The situation of women in the labor market is closely linked to their situation in other areas of society. Any intervention in the labor market must therefore be accompanied by other interventions in the other societal spheres for mutual support and sustainability of the required changes. Also, women workers constitute a heterogenous group, and the range of measures proposed thus may not all be applicable to the same extent to the different categories. Furthermore, women cannot be described as merely victims of the changes occurring in the world of work, since they are also active agents and some have been able to fully exploit and influence the changes to their benefit. The effective tackling of the risks, challenges, and problems of women in the current changing global labor market to accelerate the pace of progress in the quantity and quality of women's employment opportunities requires a multifaceted and proactive strategy and the involvement and commitment of all the key actors in the world of work—men, women, governments, employers, the trade unions, and NGOs. A clear illustration of this is the ILO's recent multidisciplinary intiative called the Interdepartmental Project on Equality for Women in Employment, which was implemented in 1992 and 1993. It generated considerable data about women workers, provided insight into gender questions in the world of work, and highlighted the urgent need for a multifaceted, integrated, and proactive approach.

The integrated holistic strategy should comprise:

- A supportive legislative framework and enforcement mechanism that includes the ratification and implementation of relevant international labor standards, especially those on equality of opportunity and treatment between men and women; the adoption of relevant laws and other provisions and directives at the national level that adequately reflect the principles contained in these standards; the strengthening of legal literacy and

information on dissemination of women workers' rights; the development of the capacity and work of labor inspectors and the other legal enforcement bodies; and the extension of existing legal and social protection to vulnerable groups of women workers.

- Gender sensitivity in the formulation of macro- and microeconomic and active labor market policy and in the analysis of their potential and real impact at every stage, including their inception and implementation.

- Women's enhanced access to the productive resources of credit, land, improved technology, and markets.

- Employment promotion and poverty alleviation.

- Improvements in the quality of women's work in terms of pay and other working conditions, occupational health and safety, job security, and the tackling of sexual harassment at the workplace.

- Equal sharing of family responsibilities and the adoption of other measures to reconcile reproductive and productive roles. The latter should include not only the provision of adequate child care facilities and maternity leave but also parental and paternal leave and family-friendly workplaces.

- Affirmative action and other measures to promote women's increased representation and participation in decision making.

- Women's enhanced mobilization, representation, and empowerment in the trade unions, employers' organizations, and grassroots and other associations, as well as in decision making. Furthermore, the trade unions should play a role in organizing women and other workers in the unorganized sectors.

- Awareness raising and gender sensitization of decision makers and the relevant actors.

- Generation of up-to-date gender-disaggregated data and analysis and the development of appropriate conceptual bases to give full visability to women's work and to provide a sound foundation for the formulation, monitoring, and evaluation of interventions.

- Dialogue between the relevant actors and coordination of their efforts to promote the quantity and quality of women's employment.

Several of the above essential elements have been stressed in some of the regional platforms for action recently adopted by the regional prepatory conferences convened for the World Conference on Women as well as by the various regional and international meetings held by the ILO as an integral part of its contribution to the World Conference. Examples of the latter are the International Forum on Women Workers in a Changing Global Environment (June 1994); the Tripartite Seminar on Women, Work, and Poverty in Africa (October 1994); The Impact of Economic Restructuring on Employment, Training, and Working Conditions of Women (October 1994); European Seminar on Women and Work (March 1994); and the Tripartite Symposium on the Problems of Women Workers in the Arab Countries (October 1994).

WHAT ROLE CAN UN INSTITUTIONS SUCH AS THE ILO PLAY IN THIS FIELD?

UN institutions can play a critical role in providing guidance to member states in the formulation and implementation at the local level of such an integrated approach as that outlined above. In a more specific leadership role, the institutions can:

- Use their international leadership role to advocate the promotion of women's equal treatment and opportunity in employment with men.

- Provide technical advice to member states on the implementation of such an integrated strategy.

- Encourage ratification and implementation of relevant international labor standards.

- Encourage gender sensitivity of, and consultation between, the relevant actors in the formulation of labor market and micro- and macroeconomic policies.

- Assist in carrying out regular research to collect up-to-date gender-disaggregated data on the changes in the labor market and their repercussions on the different categories of workers and in disseminating such data widely to guide action. Such

research work should also tackle the persistent invisibility of much of women's economic contribution through their nonmarket activities.

- Undertake technical cooperation projects with member states and the relevant national and other bodies to strengthen the capacity of women workers, especially the most disadvantaged, to improve their work situation.

- Promote the exchange of experiences among states and the relevant actors with regard to policies, concrete measures, and activities on women's employment.

- Serve as a good role model through the quality and quantity of employment opportunities provided to women working within the various UN organizations.

- Disseminate information on women workers' rights and success stories to stimulate action at the local level.

- Link up and develop strong networks, with NGOs and other relevant bodies for concerted action to enhance the effects of their activities.

The ILO has an important role to play because of its mandate, its seventy-six years of experience in this field, and its tripartite membership, which is unique within the United Nations system. It is the only United Nations specialized agency in which the three key actors in the world of work—governments, employers, and workers' organizations—are represented in all its structures and participate in formulating all of its major policies and programs. This structure can facilitate the organization's promotion of tripartite dialogue and the mobilization and active involvement of these actors in the promotion of equality of opportunity and treatment of women and men in the world of work.

CONCLUSION

The quantity and quality of women's employment are important for women's empowerment and general status in society. Furthermore, women's employment is a matter of human rights and also of economic efficiency, as it permits the harnessing of the diverse resources, skills, and potential of women in addition to men for

maximum output, growth, poverty alleviation, and sustainable development. It is thus essential to ensure that the changing global labor market creates an enabling environment for progress in this area. The close linkages between work and the other spheres of society imply that such an improvement in the situation of women workers could also contribute to improvements for women in the other areas to make women's general advancement in society a reality in the twenty-first century.

REFERENCES

ILO. 1992. World Labour Report. Geneva: ILO.

————. 1994a.*The Changing Role of Women in the Economy.* Document G.B. 261/SP/2/2 ILO Governing Body, 261st session, November 1994.

————. 1994b. *World Labour Report.* Geneva: ILO

————. 1995. *ILO and the Fourth World Conference on Women,* document G.B. 262/LILS/6. ILO Governing Body, 262nd session, March–April 1995.

ILO/International Institute for Labour Studies. 1994. *Framework Paper on Women Workers in a Changing Global Environment.* Paper prepared for the ILO International Forum on Equality for Women in the World of Work, Geneva, June 1994.

—Senior Technical Specialist, Women Workers
and Gender Questions, ILO

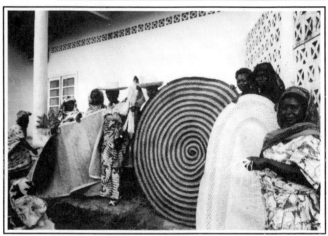

*F*ROM STABILIZATION TO GROWTH WITH EQUITY
A Case for Financing Women In Development Programs

Anne Forrester

As the United Nations system moves rapidly away from purely economistic views of development based on neoclassical models toward sustainable human development paradigms and growth with equity, we are faced with the concrete knowledge that no additional sources of finance will be available from traditional resources within the private sector, and that we must therefore ensure that existing funds are used to increasingly positive effect.

Moreover, there is increasing frustration with structural adjustment programs as the prescription for sustained and accelerated growth and development. These programs have stabilized the economy in many cases, but in the process, many countries often felt they were going backward rather than forward in meeting the aspirations of their people, particularly women, for a better life. In addition, structural adjustment has had the effect of focusing policy dialogue on short-term prescriptions for stabilization at the expense of long-term development objectives that are for, by, and of the people. There is a need to refocus the macroeconomic policy dialogue on long-term development that stresses growth with equity, with women taking their rightful place in the development equation. For this to happen, the following issues need to be addressed.

Invisibility

As a result of gender bias in economic assumptions about household activity and paid and unpaid work, women's economic contribution is largely invisible. Current national accounting systems and statistical bases provide an incomplete and unsound basis for making informed policy choices for mapping a path to growth with equity. The soon-to-be-released 1995 Human Development Report has made great strides in developing a methodology for capturing the "invisible" contribution of womens' work in national accounts.

Investing in Women As an Engine of Growth: Closing the Gap between Actual and Potential Productivity

Women's centrality in economic production has always stood in stark contrast to the discrimination they face in accessing financial, technical, and other resources that would enable them to realize their full productive potential. A recent study from Kenya makes a compelling case for investing in women farmers to raise overall productivity and growth. According to the study, "If women had the same human capital endowments and used the same amounts of factors and inputs as men, the value of their output would be increased by some 22 percent. Thus, women are quite possibly better, more efficient, farm managers than men." The study further states that by "simply raising the productivity of women to the same level as men could increase total production by 10 to 15 percent."

In addition to direct investment, an important tool for unleashing women's potential is devising effective gender-sensitive incentives that encourage women's full productivity. One instrument that has been shown in some circumstances to release the potential of women is that of small-scale credit to the urban and rural poor, an area in which there was an early analysis and attempts to focus on the specific needs of poor women. Support of various kinds to small-scale activities of the poor has been a key mechanism for strengthening productivity, facilitating the development of a cash economy, strengthening connections with the formal banking system, introducing formal financial and accounting procedures into the informal sector, and assisting in the attainment of similar finance-related goals. It has thus been a significant adjunct, albeit on a local scale, to the economic modernization that is the universal concomitant of development.

Because much of this labor is unvalued, and therefore it is assumed that no measurable financial return can be expected from investing in it, it is not eligible for formal financial assistance. Credit cannot be obtained, for example, to purchase labor-saving household devices, nor to buy fertilizer or improved seed unless the crop is intended for sale.

SMALL-SCALE CREDIT

One source of economic resources to which women have had some access has been local, indigenous credit systems, many of which have either been outlawed by governments or ignored by the formal banking system, which is often a nationalized concern. Frequently the terms of loans from informal sources such as moneylenders are extortionate.

More than five hundred million economically active people run small and microenterprises in the informal sector. Of these entrepreneurs, a significant proportion are women, as many as 50 percent in a number of countries of sub-Saharan Africa. Fewer than ten million of these enterprises have access to financial services other than moneylenders. Conventional banks concentrate only on the top 25 percent of the economically active population, overwhelmingly in the formal sector. By contrast, such innovative ventures as the Grameen Bank reach less than 2 percent of low-income entrepreneurs; more than 80 percent of these borrowers are women.

In sum, the available formal and informal loan resources are not reaching the informal sector, preventing many dynamic entrepreneurs from making their full potential contribution to economic growth. A significant proportion of those excluded are women, who have very good records as loan recipients, and who have special financial needs.

We have long known the reasons for this worldwide mismatch. The vast majority of low-income women lack the collateral requirements of conventional banks. Their low levels of education also limit their ability to keep business accounts and records, or to take advantage of conventional managerial and technical training. From the bank's point of view, it is too costly to make the very small loans, typically of one hundred dollars or less and often only about twenty dollars, for which these women ask.

The exclusion of low-income female entrepreneurs from formal credit mechanisms is ironic. Their repayment rates average well over

90 percent, even when the interest rates on the small sums they borrow soar to over 20 percent at conventional banks and 50 percent or more from moneylenders. These women do not need subsidies. Provided banks can keep the overhead (administrative cost and allowance for bad debt) below 6–8 percent, there is no reason why loans to female entrepreneurs could not be economically feasible. However, many small-scale credit institutions have overheads of 15–20 percent. This is partly due to inefficiencies, but also to the fact that the amount of administrative support required by illiterate borrowers is relatively high.

The question of the famed low default rate of women is an important one. It is often cited as an indicator of the success of credit schemes. However, many of these schemes are providing loans to women under conditions of extremely limited demand for their products or services. They are unable to sell the buns that they bake, the bricks that they press, or the uniforms that they sew because either the market is flooded with similar products or local purchasing power is too low. Under such circumstances women divert funds from other sources, such as beer brewing or remittances from wages, to repay loans, with a net result of a reduction in their disposable income.

Very importantly, however, in a dynamic economy such small-scale enterprises can become an engine of growth that strengthens the formal sector: small and microentrepreneurs spend much of their turnover in purchasing inputs from formal businesses. In addition, groups of such entrepreneurs can and do increase social services by mounting self-help schemes for health and childcare, home improvement, and the teaching of literacy and marketable skills—in short, the very social safety nets that debt-ridden governments find increasingly difficult to provide.

Indeed, some have made the argument that small-scale credit activities should be viewed as part of a social welfare paradigm, rather than as a financial instrument contributing to growth. Under this argument it is pointed out that examples of small-scale informal producers demonstrating marked increases in productivity are limited. Much more common the families that are able to increase their income and/or savings slightly while remaining at the same general economic level. Credit under these circumstances serves to lift poor families somewhat from the lowest rungs of poverty, but does not

generate the significant increases in productivity necessary to bring about financial transformation.

A number of innovative approaches have demonstrated over the last two decades that NGOs, cooperatives, credit unions, grassroots savings groups and even commercial banks can provide the financial services, information, and skills needed to save low-income entrepreneurs from destitution. One such group is in India, the Self-Employed Women's Association—known by its acronym SEWA, which means "service" in Hindi—initially set out in 1972 to create a credit program that would help low-income women escape from indebtedness to moneylenders, large landholders, middlemen, and traders who weakened their bargaining position. When it set up its own bank in 1974 to provide its members with services denied them by the rigidity of the formal, nationalized banking system, SEWA was opposed by those very bankers. It nonetheless began offering its members means to move beyond subsistence: savings and fixed-deposit facilities; credit for productive activities; legal, accounting, technical, and management services, including wholesale purchases of raw materials, equipment, and tools; and deposit-linked group insurance. These services have continued to expand and now also encompass training in plumbing, carpentry, radio, repair and other traditionally male occupations.

Most microlenders such as SEWA attain their low default rates by making loans to small groups in which mutual accountability and peer honor guarantees timely repayment. The small sums they borrow not only lead to capital formation but also build social capital through their association with one another and with the microlender. Such associations foster self-recognition and self-confidence. They often go far beyond the initial purpose of the loan as both borrowers and lender reach out to create alliances with government authorities, development organizations, bankers, and business leaders.

Structural reform must entail the reform of financial systems that now serve only the few. Neglecting the energy and ingenuity of the women whose unpaid work has subsidized all forms of society's wealth since prehistory is not only short-sighted but dangerous. It risks reinforcing structures that perpetuate poverty, among them the structure of gender relations that exploits women's unpaid labor, denies the value of that labor, and diminishes women's opportunities for gainful work outside the home.

By contrast, developing and strengthening institutions that give credit where credit is due both tackles poverty and, in appropriate circumstances, generates broad-based economic growth at the same time. If development is finally geared to enlarging human choice, financial reform must not only increase productivity but also enhance human dignity, a force whose creativity and strength has too long been ignored by development planners, public and private.

One such innovation could be to generalize mechanisms whereby the savings of small-scale producers could be invested in their own communities. Credit schemes are often accompanied by savings schemes: potential borrowers have first to demonstrate the capacity to save. It is precisely these savings that are loaned to group members, sometimes reinforced by funds provided by donors. To the extent that these funds are deposited in formal financial institutions, however, they are invested by these modern sectors of the economy. Cooperative societies give a model here, in which virtually all saved funds are locally loaned. Cooperatives are often driven by corruption or suspicion of corruption, however, and are notoriously inefficient. Moreover, their loan policies tend to reflect the priorities of the more vocal members—principally men. Strengthening women's capacity to participate in, manage, and direct cooperatives and other financial intermediaries could well be one way forward.

Another possibility would be to follow the example of the People's Bank of Nigeria, which was established in 1989 as part of concerted government and NGO effort to integrate women into the socioeconomic and political mainstream. The principal activity of the bank is to make collateral-free loans to underprivileged women, and the poor generally, who lack access to credit facilities available from commercial and merchant banks. Since 1989, 348 branches have been opened, of which 68 are mobile banks that take their services to the people, especially women, on weekly market days. Several focused schemes have been initiated to enhance the services offered by the bank and to respond to the specific concerns of clients, particularly women. These include the Banking for Health Scheme; the Savings Scheme; the People's Emergency Deposit Scheme; and the Street Gangs Scheme, among others. A total of about thirty million dollars has been disbursed to about 650,000 beneficiaries, and over 75 percent of this amount has been given to women.

CHALLENGES FOR FINANCING WOMEN IN DEVELOPMENT PROGRAMS

The prescription we know all to well. It is time that we set challenging targets for policy makers, decision makers, and bankers that will make a difference in the contribution women can make to advancing and sustaining human development.

By the year 2000:

- Incentives should be created for banks to amend their lending policies regarding collateral required of women. Lending policies could be based instead on a proven track record in repayment of informal loans.

- Legislation should be created that would require banks and other lending institutions to eliminate practices requiring a husband's consent or cosignature.

- Gender-sensitive incentives should be designed to ensure that the full potential of women's work is unleashed as an engine of growth.

- Support should be given to women's active participation in all institutions of governance and civil society, including financial management institutions.

—Deputy Director, Regional Bureau for Africa UNDP

8

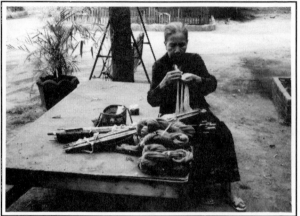

Photo by V. Gregor

Anna Grossman/The Earth Times

*W*OMEN AND THE ENVIRONMENT IN DEVELOPING COUNTRIES
The Challenge of Implementing Agenda 21

Filomina Chioma Steady

GENDER EQUITY AND ECOSYSTEM BALANCE: THE CHALLENGE FOR SUSTAINABLE DEVELOPMENT

How does one situate concerns for gender equity within the sustainable development debate? To begin, let us first examine the definition of sustainable development as used by the Brundtland Commission. Sustainable development is "development that meets the needs of the present without compromising the ability of future generations to meet their own needs" (World Commission 1987). This definition recognizes the importance of linking environment and development and promoting the principles of intergenerational and intragenerational equity while ensuring ecosystem balance. It also carries a hidden warning that unrestrained economic growth can lead to ecological destruction. Both have important implications for women.

Given the Brundtland definition, how well is development meeting the needs of the present? What does sustainable development mean to poor women in a developing country who, as primary resource user's are increasingly dependent on diminishing resources and often have to bear the burden of failed development policies and programs operating at both the international and national levels? Devoid of choices, how can such women possibly preserve the

environment for their children's future when they can barely survive
in it themselves in the present? Needless to say, this definition as it
stands does not meet the needs of the present for everybody, particu-
larly not poor women in developing countries, who are the focus of
this paper.

ENVIRONMENTAL DEGRADATION: A SYMPTOM OF A LARGER SOCIOECONOMIC CRISIS

The global degradation of terrestrial and marine ecosystems and the
implications for women are now well known thanks to the 1992 Rio
Earth Summit. These are linked to such problems experienced by
developing countries as economic recession, chronic debt burdens,
reverse resource flows, and negative structural adjustment condi-
tionalities. A decline in prices for their exported commodities affects
their ability to import vital medical supplies, technology, and fuel
and forces them to produce even greater quantities of cash crops for
export at the detriment of food production.

The strange logic that fuels the world economic system even
compels African governments to produce tons of coffee, cocoa, and
cotton for export at declining world prices and for the benefit of
others, while famine ravages millions of their own people, (Engo
1991). Between 1983 and 1984 Burkina Faso, Chad, Mali, Niger, and
Senegal produced record amounts of cotton, to the order of 154
million tons of fiber, up from 22.7 million in 1961–62, at a time when
severe drought and famine were affecting the region (World Commis-
sion 1987).

According to one estimate, the poorest 20 percent of the world's
population lives in ecologically fragile and vulnerable areas. Of this
group it is estimated that 80 percent of the people in Latin America,
60 percent in Asia, and 51 percent in Africa live in areas of very low
productivity with a high degree of susceptibility to environmental
degradation (Leonard et al. 1989). These people are generally given
low priority in official development policies, and women are dispro-
portionately represented among the poorest population groups
(UNDP 1992).

Poverty and environmental degradation are not confined to develop-
ing countries. Unemployment is a major problem in most industrialized
and postindustrialized countries. The number of homeless who

sleep in the streets of New York, Miami, and other big cities under unsanitary conditions is growing and far exceeds official estimates when children are counted.

The poor of the north also bear the brunt of environmental pollution, particularly the women and children. Pesticide poisoning with disastrous damage to women's reproductive organs occurs routinely among migrant farm workers in California (Huerta 1993). Most of the landfills and dump sites for hazardous wastes are located in poor neighborhoods often inhabited by people of color (Cole 1990). At the international level this imbalance is also evident in the trend toward exporting hazardous wastes to the developing world, particularly Africa, despite the Basel Convention, the London Dumping Convention, and the Bamako Convention.

International economic policies and globalization trends that create gross disparities between and within nations, especially between social groups and the sexes, are among the root causes of the global crisis of poverty, ecosystem imbalance, and environmental degradation as exemplified at the Earth Summit, the International Conference on Population and Development, and the World Summit for Social Development.

WOMEN AND THE ENVIRONMENT IN DEVELOPING COUNTRIES

Women have been associated with the environment in both positive and negative ways. On the positive side, the nature of gender relations, notably the sexual division of labor, often brings women into direct and intense daily contact with the total ecosystem, especially where this contact involves the development, management, and use of natural resources. In many rural communities in developing countries, it is women who perform most of the duties related to farming, food processing, water and fuel procurement, animal husbandry, waste disposal, and household management.

In some African countries women contribute as much as 75 percent of household production. This can involve procuring items from the forests such as food, fuel, fiber, fertilizer, fodder, medicinal herbs, and building material. Through their work, many rural women ensure the flow of biomass from forests to animals, plants, and humans and throughout the ecosystem. On a typical day a rural

woman in some parts of Africa could spend an average of three hours fetching water from six to eight kilometers away. During periods of drought she has to walk even farther. (Pala Okeyo 1978; Dankleman and Davidson 1988)

In parts of Asia, particularly in India, the typical rural woman works twelve to fifteen hours a day gathering firewood and water, growing food, collecting fodder, tending domestic animals, cooking, cleaning, and caring for children, the sick and the elderly (Agarwal 1992). In the Caribbean, women are responsible for 80 percent of domestic food production and distribution (Wiltshire 1993). Similarly, a large percentage of women in Latin America are involved in agricultural work as well as domestic tasks requiring the use of natural resources (Global Assembly 1991).

On the negative side, women are often among the primary victims of the synergistic effects of environmental degradation and poverty (Steady 1993). Because poor women rely heavily on natural resources, they are among the first to notice and feel the effects of environmental stress, often increasing their workload, reducing their access to land and other resources, and undermining their health.

Women's health can become endangered by environmental degradation resulting from a scarcity of clean water, desertification, exposure to toxic chemicals and hazardous wastes, and exposure to infectious diseases through caring for the sick. Agricultural inputs such as pesticides, which are usually handled by women have been shown to have negative effects on human genetic structure and to affect women's reproductive systems, pregnancy outcomes, and fetal development.

Women's dependency on firewood for household fuel has been associated with environmental degradation. Activities that destroy forests are related more often to large-scale industrial and commercial ventures, logging, grazing for commercial meat production, cash cropping, urbanization, timber and pulp extraction for export, and intensive hydroelectric development. Rapid population growth, resulting in environmental degradation and poverty has sometimes been attributed to the failure of women to control their high fertility rates. In reality the issue is much more complex, and it is more likely that poverty, has a greater influence on fertility rates than the other way around.

Fertility does not exist in a vacuum. To the poor, children can represent a real or potential source of income, labor, and security during old age. High infant mortality rates and high infertility rates in some areas of Africa continue to act as motivating factors for large family size. The International Conference on Population and Development has demonstrated that fertility levels are determined by social and economic factors, which affect women's status, educational level, and access to reproductive health care services.

Consequently, a reduction in fertility rates will require greater equity in the distribution of natural resources, reductions in economic disparities at global and national levels and between men and women, access to safe and affordable contraceptive methods and information on family planning, and the alleviation of poverty (United Nations 1992). In particular, women's human resource capabilities have to be developed through education, training, access to productive resources, and employment, as well as through the enhancement of their legal rights and their increased participation in decision making.

The relationship between population growth and the environment is further complicated by disparities in consumption patterns. Although the UNCED has projected population growth to reach an unsustainable level of 5.5 billion by the year 2020, the rate of consumption also gives cause for alarm. Lifestyles of the most affluent societies of the world show that "the average resident of an industrialized country consumes three times as much fresh water, ten times as much energy, and nineteen times as much aluminum as someone in a developing country" (Durning 1992). As stated in the first world conservation strategy and amplified at the Earth Summit, "The predicament caused by demanding scarcer resources is exacerbated by the disproportionately high consumption rates in developed countries" (IUCN 1980).

An emphasis on reduced consumption is also required for a more balanced approach to sustainable development. Fifty-two years ago, Mahatma Ghandi made a startling observation on this question at a time when science and technology seemed infallible in providing all the answers related to development. When asked by a journalist whether he wanted India to have the same standard of living as Britain, he replied: "To have its standard of living, a tiny country like

Britain had to exploit half the globe. How many globes will a large country like India need to exploit to have a similar standard of living?" (quoted in Kamla 1992).

THE EARTH SUMMIT AND WOMEN

The United Nations Conference on Environment and Development, otherwise known as the Earth Summit and held in Rio in June 1992, established women as protagonists in environmental management and in the conservation of natural resources beyond any doubt. It affirmed that sustainable development can best be achieve with the advancement of women in the development process. Principle 20 of the Rio Declaration states: "Women have a vital role in environmental management and development. Their full participation is therefore essential to achieving sustainable development."

In *Agenda 21*, activities for the incorporation of women are mainstreamed throughout the sectoral and cross-sectoral sections and in the section on the means of implementation as well as the section on strengthening the role of major groups. This section includes chapter 24, "Global Action for Women Toward Sustainable and Equitable Development," which contains specific agreements by governments to strengthen the role of women in creating and implementing sustainable development strategies and to eliminate all obstacles to their equal and beneficial participation, including decision making. In the area of policy, it emphasizes activities for the implementation and enforcement of legal and constitutional measures promoting gender equity and activities for strengthening the legal capacity of women.

Agenda 21 endorses Gender-oriented research, policy analysis, and information gathering and dissemination as essential prerequisites for policy formulation. Emphasis is placed on incorporating women's knowledge, contributions, and experiences in ecosystem management in the data base used for planning and for implementing programs for sustainable development. Capacity-building measures include the expansion of educational and training opportunities for women.

THE CHALLENGE OF IMPLEMENTING *AGENDA 21*

There are four main obstacles to implementing *Agenda 21* and other recommendations from Rio regarding women's involvement in

promoting sustainable development. The first is related to economic and resource constraints faced by both developing and developed countries that are facing economic problems ranging from large-scale unemployment to intractable recession.

A review of trends reveals the following realities for developing countries: According to the Africa Recovery, decline in commodity prices on the international market, coupled with declining resource flows, has resulted in Africa losing $50 billion since 1986, which is far less than the amount given in aid. Africa's indebtedness rose from $140 billion in 1982 to $272 billion in 1990. "Africa's exports grew by an average of 2.5% since 1986, yet the unit value of these exports fell to two thirds the level that prevailed in 1980. . . . As a result, the purchasing power of a given amount of African exports had fallen by nearly half by 1990" (United Nations 1990) and is getting worse.

In Asia the debt problem is particularly marked. In 1990, for example, the fiscal debt of just one country, Bangladesh, was $11.3 billion dollars. During the 1980s many Southeast Asian countries were pressured into adopting structural adjustment conditionalities by international fiscal institutions. The result, according to one report, is to impose severe constraints on resources vital to the poor, and many of these countries in Asia are forced to vigorously promote export-led growth at the expense of the people and the environment (Women's Feature Service 1992).

Most countries in Latin America and the Caribbean are faced with foreign debt-servicing burdens, structural adjustment policies, economic recession, and inflation. According to the United Nations Economic Commission for Latin America and the Caribbean (ECLAC), resources amounting to $223 billion dollars were drained out of the region between 1982 to 1990. In addition $503 billion went into payments of debts, of which $313 billion were absorbed by debt-servicing costs (Women's Feature Service 1992).

A second major constraint is related to structural problems that stem from faulty development policies and programs. Most programming activities are dominated by "experts," most of whom are men, many of whom have not yet undergone training in gender sensitization. Though well meaning, they are not always aware of the gender implications of program planning and implementation. Other problems of implementation include the limitations of institutions of

delivery, such as international agencies, and distortions in the data base used for planning (Rogers 1980). Program delivery can also derail the best efforts at implementation. In addition, frequent devaluation of local currencies can seriously undermine a country's purchasing power.

The low level of participation of women in decision-making positions is the third obstacle. According to data received by the secretariat of the Earth Summit based on responses to a questionnaire on "the role of women in sustainable development," almost all countries noted the low rate of participation of women in decision making. Some of the reasons cited as inhibiting factors include socioeconomic forces, perceptions of women's traditional roles, and gender bias. A number of countries indicated that women's participation was increasing in decision making at the level of middle management and in some professions (Steady 1992). At present only about 15 percent of parliamentarians worldwide are women. It is not surprising then that at the Earth Summit, only 15 percent of the delegates were women.

A fourth obstacle is the dominant ideology that drives and influences the application of science and technology. For the most part, development has been propelled by the ideology of the domination of nature by science proposed by Sir Francis Bacon in the seventeenth century. By extension it implied the promotion of economic growth at all cost. This ideology was systematically challenged by the critical-theory movement of the Frankfurt school during the 1920s and 1930s as likely to result in a "revolt of nature," in other words, an ecological crisis. Nature has to be understood "not merely as something external to man but also as an internal reality" (Leiss 1972).

According to Women in Development, Europe (WIDE), an environmental group composed of northern women, "The ecological crisis can be seen as the inevitable outcome of the logic and practice of a development based on a science and technological expertise whose object since the enlightenment has been to turn everything into resources for appropriation and to dominate people and nature for economic reasons" (*WIDE Bulletin*, 1992).

Despite advances in science and technology, over one billion of the world's population live in poverty and 1.5 billion still lack clean water. Most technologies used in agriculture in many developing countries are inappropriate. Where plowing is essentially a male occupation in parts of Africa, introduction of the plow reduces the

workload for men but increases it for women, since the area of farming by hand has now increased through plowing. In other cases, the introduction of farm machinery has tended to displace women from their traditional land cultivated for family sustenance. The intensification of resource use through monocultures and extractive, export-oriented production patterns have led to an erosion not only of the natural resource base but also of tribal and peasant societies, their customary land rights, the local knowledge base, and the integrity of their social and cultural systems (Agarwal 1992).

Solar energy and other renewable sources of energy have a vast potential as an alternative to fossil fuel and can contribute to women's health and well-being as a labor saving device. Yet the use of solar energy in most developing countries is still limited.

Beneficial traditional practices such as intercropping, which provided safeguards against adverse climatic conditions and controlled weeds and pests, have unfortunately not been promoted by development agencies and national governments. The pattern established during the colonial era of favoring large plantations, and cash crop production to the disadvantage of the small farmer, many of whom were women, continues to operate and to determine agricultural policies and priorities. This pattern has often led to unsafe and environmentally harmful agricultural practices. The most serious issue in this regard concerns the use of pesticides, such as DDT, that are often banned in the West but promoted by multinational companies and some aid agencies in developing countries.

ELEMENTS OF A GENDER SENSITIVE IMPLEMENTATION FRAMEWORK
Consultative Process in Policy Formulation, Planning, and Implementation

Policies on sustainable development and the relevant sectors must include a consultative process in which women's perspectives, needs, concerns, and aspirations are fully represented. Important elements of such policies and implementation strategies must include provisions for the development of women's capacities to serve as policy makers, decision makers, advisers, planners, technical experts, and scientists. Planning approaches have to be reconceptualized in more gender-sensitive ways, relying more on holistic and integrated approaches

linking both the domestic sphere and the public sphere in which women work.

To ensure the holistic and participatory aspects of sustainable development, women should be involved both as community activists and beneficiaries of sustainable development. Women's leadership at the grassroots level and in traditional spheres needs to be harnessed to play an important advocacy role in the development of gender-sensitive policies. Policy dialogue sessions involving communication between grassroots women and policy makers should be encouraged, as well as meetings among the various stakeholders.

Legislation

Legislation should be enforced to support the implementation of development policies and plans designed to mainstream both environmental and gender concerns. Strengthening women's legal capacity would require the enforcement of legislation guaranteeing their rights and access to land and other natural resources. The implementation, enforcement, and monitoring of domestic legislation relating to the Convention on the Elimination of All Forms of Discrimination against Women should be a priority. Equally important is the promotion of legal literacy relating to this convention and relevant environmental conventions.

Land tenure reform—often influenced by a colonial legal framework, as was the case of Kenya and Zambia—can also serve to worsen the situation for women, resulting in the displacement of women and an alteration in the gender division of land resource use (Pala Okeyo 1978). Even more detrimental is the tendency for land tenure reforms to displace women from their traditional gathering, herding, and farming communities, rendering them legally landless.

Promoting Research, Gender Analysis, Monitoring, and Evaluation

Sustainable development would require a multisectoral approach and the integration of environment and development. Some of the approaches developed through gender analysis, which to a large extent uses a mainstreaming methodology, could contribute to such integration. Gender analysis should be conducted at the earliest stages of all project designs, and regular training of staff in gender

analysis and gender sensitization should be institutionalized. Research should also be conducted on women's knowledge of environmental management and conservation for incorporation into data bases used for planning women's contributions.

The participation of women should be ensured in monitoring and evaluation activities. Mechanisms should be established to evaluate and monitor the following:

The rate of incorporation of women in sustainable development, such as the equality of opportunities to training in the fields of science and technology, sustainable agriculture, hydrology, and so on.

The gender-differentiated impacts of development programs and projects on women, for example, the use of pesticides, herbicides, and fertilizers on female agricultural workers.

The displacement and loss of income as a result of the construction of dams.

The erosion of the natural resource base on which women in the informal sector depends.

Valuing Women's Contributions

Public recognition and valuation of women's contributions to sustainable development on a regular basis would serve to motivate other women and help build on the successes of past achievements. One such successful effort at the international level worthy of emulation at the national level was the Global Assembly on Women and the Environment, held in Miami in November 1991.

Women's perspectives should be valued and encouraged and community participation facilitated in all aspects of project design, planning, implementation, and monitoring, especially those originating from outside the country.

Augmenting Financial Resources for Women's Activities

There is an urgent need to reorient national budgets to increase and allocate additional resources toward sustainable development and less to military and other wasteful and unsustainable adventures. A substantial percentage of the budget should go toward supporting

women's efforts in natural resource management and allocating adequate resources for rehabilitation and conservation measures by women.

Above all, action needs to be taken at the international level to remove some of the constraints on national economies. Consequently, improving the financial situation would require reforming the international economic system to reduce the debt burden of developing counties, promote equity in international trade, halt the flow of resources from poor counties to rich counties, and halt the negative effects of structural adjustment programs.

Developing More Gender-Sensitive Capacity Building Measures

The participation of women should be an essential requirement in programs related to designing, developing, and applying environmentally sound technologies, new and renewable sources of energy, waste reduction, and the control of toxicity in the home and the workplace.

Expansion of Women's Training Opportunities in Scientific and Technological Fields

Special efforts should be made to promote and enhance, through scholarships and fellowships and affirmative-action measures, the full and effective participation of women at all levels in the fields of science and technology through equal access to both scientific and technological education, advanced postgraduate training, and professional careers in these fields as a matter of priority. Such efforts should also integrate the contributions of the natural, engineering, and social sciences into the formulation of environment and development policy, taking due account of the responsibility of women in their role as educators and transmitters of social norms and values and in shaping the social and ethical context in which science is performed.

Promote Primary Environmental Care (PAC)

An Oxford Committee for Famine Relief (OXFAM) concept developed by the late Joan Davidson is gaining popularity and is being promoted by UNIFEM. Based on the principles of primary health care, Primary Environmental Care emphasizes a "bottom up" participatory approach

that includes participation in decision making by all interest groups. It promotes "preventive" as well as "curative" environmental action. It also promotes sectoral integration at the local level as well as information dissemination, budgetary efficiency and flexibility, and training. PAC is important for women (as is primary health care) and provides an opportunity for mobilizing women at the grassroots level for environmental protection in a way that will recognize and reward the participants.

Strengthening Women's Organizations and Movements and Developing Partnerships

Women's environmental organizations and movements hold the key to sustainable development in many countries. They could be strengthened through outreach programs by governments, nongovernmental organizations, and institutions of higher learning. Training could be provided in technical areas on waste reduction, ecosystem management, sustainable agriculture, use of new and renewable and more energy-efficient alternatives, and protection against environmental hazards. Every effort should be made to develop partnerships and alliances between women's organizations and other organizations working for change toward a more equitable and sustainable development for all peoples.

CONCLUSION

The participation of women in developing countries in sustainable development can help restore equity and ecosystem balance and validate the true definition of sustainable development. Women's perspectives can lead to a critical examination of the imperatives of economic growth and its impact on the environment. They can also help to promote more sustainable and equitable sustainable production, reproduction, distribution, and consumption patterns. Furthermore, decentralization of decision making and greater participation of grassroots populations are desirable goals that can be facilitated by the involvement of poor and disenfranchised women in both the south and the north.

The perspectives of women who have been victims of environmental degradation can help promote greater sensitivity about the vulnerabilities of the planet. Similarly, the perspectives of women in the developing world is essential to promote an alternative worldview

that will truly representative our global reality. This can also facilitate the development of new concepts that might lead to ecological and economic balance and alternative models of development.

Values that reflect global pluralism are likely to be more sustainable than the current destructive and unsustainable course of development. The current dominant model of development is not sustainable and cannot be implemented by the majority of the developing world. There is a need to reconceptualize a development paradigm that can promote equity, social justice, sustainability, and self-determination.

The concept of sustainable development established standards that are essentially moral and ethical. The task of maintaining sustainable development will require more than legislation and agreements of policy. It will have to involve the full participation of all people, especially women. Ultimately success will depend on changes in values regarding our relationships with each other and with our planet as gendered earthlings or as an endangered species.

By incorporating the experiences and contributions of women in developing countries to environmentally sound development, we can enhance our knowledge in ways that can better prepare us for a people-based strategy for sustainable development. We are not suggesting a return to the past but rather a retrieval and centering of our hidden values often made invisible because the main guardians of these values—women—have not been the central players in policy and decision making.

REFERENCES

Agarwal, B., ed. 1992. *Gender and the Environment: Lessons from India: Proceedings from the International Conference on Women and Biodiversity*, Cambridge, Mass.: Kennedy School of Government, Harvard University.

Cole, C. 1990. "Triple Jeopardy: Race, Poverty, and Toxic Waste" Response 22, no. 4 (April).

Dankleman, I and Davidson, J., eds. 1988. Women and the Environment in the Third World. London: Earthscan.

Davidson, J. 1991. "Primary Environmental Care: An Oxfam Approach", Paper presented at the Women's Caucus, United Nations conference on Environment and Development Preparatory Meeting, Geneva, 1991 (October).

Durning, A. 1992. How Much Is Enough? The *Consumer Society and the Future of the Earth*. The Worldwatch Institute Alert Series. New York: Norton.

Engo, R. 1991. Testimony presented at the World Women's Congress for a Healthy Planet, Miami.

Global Assembly on Women and the Environment. 1991. *Report and Recommendation* Miami.

Huerta, D. 1993. "The Impact of Poverty and Environmental Degradation on Women Migrant Workers." In F. C. Steady, ed. *Women and Children First: Environment, Poverty, and Sustainable Development*. Rochester, Vt.: Schenkman Books.

International Union for the Conservation of Nature and Natural Resources. 1980. *First World Conservation Strategy*, Gland, Switzerland.

Kamla, B. 1992, 1993. "Some thoughts on development and sustainable development." *ISIS International* 1992, no.4, 1993, no.1.

Leiss, W. 1972. The *Domination of Nature*, New York: Braziller.

Leonard, H. J. et al. 1989. *Environment and the Poor: Development Strategies for a Common Agenda*. New Brunswick, N.J.: Transaction Books.

Pala Okeyo, A. 1978. "Women's Access to Land and Their Role in Agriculture and Decision-Making on the Farm." Discussion paper, Institute for Development Studies, University of Nairobi.

Rogers, B. 1980. *The Domestication of Women: Discrimination in Developing Countries*. New York: St. Martin's Press.

Steady, F. C, ed. 1992. *National Reports: Selected Case Studies on the Role of Women in Sustainable Development*.

———.1993. Women and Children *First: Environment, Poverty, and Sustainable Development*. Rochester, Vt.: Schenkman Books.

United Nations. 1990. *Africa Recovery* 4, nos. 3–4. New York.

———. 1992. World Population *Monitoring*. New York: United Nations.

———. 1993, Agenda 21: *The Programme of Action from Rio*. New York: United Nations.

United Nations Development Programme.1992. *Human Development Report*, Oxford: Oxford University Press.

WIDE Bulletin. 1992, no. 1. Rome: SID.

Wiltshire, R. 1993. "Problems of Environmental Degradation and Poverty" in F. C. Steady, ed. *Women and Children First: Environment, Poverty, and Sustainable Development*, Rochester, Vt.: Schenkman Books.

Women's Feature Service. 1992. *The Power to Change: Women in the Third World Redefine Their Environment*. New Delhi: Raj Press.

World Commission on Environment and Development. 1987. *Our Common Future*. Oxford: Oxford University Press.

*—Special Advisor on Women in Sustainable
Industrial Development, UNIDO*

PART III

STATEMENTS

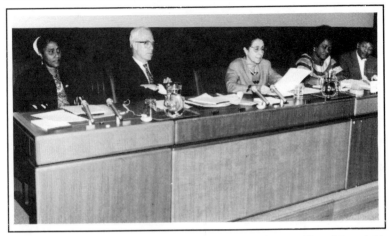

Chafika Meslem delivering her Keynote Address at the Seminar. From left to right: Olubanké King-Akérélé, Reginald van Raalte, Chafika Meslem, Filomina Chioma Steady, and Remie Touré. UNIDO/326200A/*SCHWANG*.

Filomina Chioma Steady, Chair. UNIDO/326210A/ *SCHWANG*.

A.Tcheknavorian-Asenbauer,
Managing Director, Industrial Sector
and Environment Division, UNIDO.
Founder of the Forum of Women
Professionals. UNIDO/326212A/
SCHWANG.

Reginald van Raalte, Managing Direc-
tor, Administration. UNIDO/326208A/
SCHWANG.

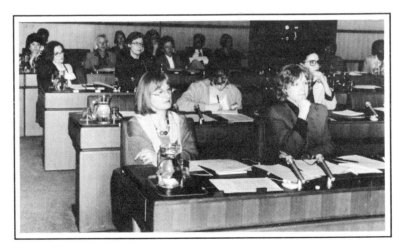

Participants at the Seminar. UNIDO/326214A/SCHWANG

Photo by Nancy Falcon-Castro.

*C*HAIR'S OPENING REMARKS

Filomina Chioma Steady

As a participant and observer of events at the UN for many years, I cannot think of a more opportune time to reflect and deliberate on the situation of women and the United Nations, both in terms of the impact of women as a group on a historically male-dominated institution and in relation to the UN's substantive agenda concerning questions of equality, development and peace, the three themes of the UN Decade for Women and the Beijing conference.

Mainstreaming gender issues in the UN has without doubt had significant impacts. More appropriate conceptualization of words like *development* and *work* resulting from gender analysis have served to enrich and promote more realistic activities. Judging from the disagreement over the word *gender* at the last Prep Conference, there are signs that we may have to reinvent the word *gender*. It is clear from its current usage that, at least analytically, we have made the quantum leap from viewing women in isolation to adopting a dynamic and systemic view in which the relations between men and women serve as organizing principles of most human societies. Gender roles being culturally constructed, are subject to change. We have to ensure that such change benefits women as well as men.

It is indeed an opportune time to consider new horizons for the agenda for women as we cast our eyes toward Beijing and the twenty-first century. In the present century, women have been relatively newcomers to the United Nations and to the dynamic interplay of power relations between nations. In the next century they will be more established as players in the game of multilateralism, and their impact will be more felt both within and outside the UN

system. The woman of the twenty-first century will expect more, demand more, and will be deserving of more. She will indeed be different. If she takes the UN seriously and studies the plans and programs that have emanated from several conferences of this century, she will have great expectations about her social, economic, political, and personal advancement. No century has promised women more.

Since the first breakthrough at the Earth Summit, which recognized women as major protagonists in promoting sustainable development, the impact of women on international events dealing with broad-ranging development topics rather than just women has mushroomed and has been overwhelming. The Human Rights Conference, in following the mainstreaming lead from UNCED, asserted that women's rights were human rights. The International Conference on Population and Development and the World Summit for Social Development have elaborated on the theme of the empowerment of women.

But in these days of skepticism about multilateral cooperation, one might well ask the following questions: What are all these agreements and commitments going to mean for the woman of the twenty-first century? Will they be translated into concrete measures and tools with which she can empower herself, or will they simply remain words on paper?

Although these are legitimate questions, the critical question to explore is, What kind of woman will constitute the majority of women in the twenty-first century? Will it be the woman who is given greater opportunities for education and career advancement and for participation in decision making at international, regional, and national levels, or the woman still crippled by poverty and the lack of educational, vocational, and other opportunities and deprived of her legal rights?

Both the world and the UN, which represents it, appear to be at a crossroads. The survival of our physical world, our planet, is as much a cause for concern as the survival of the United Nations as we know it.

The United Nations has had twenty years to advance the status of women. At this seminar we will learn further of its successes and failures. In fact, the organization was already committed to equality for women even from the days of the League of Nations. In the face

of major international changes, globalization trends, liberalization policies, regional integration, and increasing threats to peace, this is becoming a serious challenge.

So when we reflect on past achievements of the UN in relation to the agenda for women in promoting action for equality, development, and peace, we have to propose new horizons to accelerate the elimination of numerous obstacles that still impede the advancement of women.

We have before us a rich and full agenda on themes ranging from women as major actors in promoting sustainable development to women in field operations. Last but by no means least is the important theme of improving the status of women in the UN so that the organization can become a good role model and beacon to the rest of the world.

—*Chair, Seminar on Women and the United*
Nations Reflections and New Horizons

10

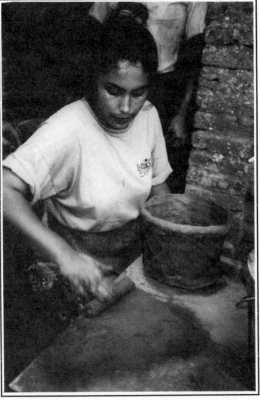

Photo by Ms. Biering.

KEYNOTE ADDRESS

Chafika Meslem

It is not without reason that the Fourth World Conference on Women takes place during the year of celebration of the fiftieth anniversary of the foundation of the United Nations. When planning the conference we were conscious of the symbolism and we were conscious, too, that it was an appropriate time to reflect on women and the United Nations—to look backward in order to better look forward. I would like to do just that: look at from where we have come, to see how far, and from there to suggest where our new horizons might be.

The United Nations Charter was the first international document to recognize the equal rights of both men and women. To see how revolutionary that was, we need only to recall that in 1945 half of the government signatories to the charter did not grant women unrestricted rights to vote, no woman had yet been elected as head of state or government in the history of democratic society, and it would be almost thirty years before the first woman became an assistant secretary-general of the United Nations. And yet women, as members of delegations, were present at its birth. Shortly after the United Nations was formed, 22 percent of the professional staff were women, but at the lower level. Women themselves believed that the organization could remove obstacles to their advancement; they saw it as a public arena that could be more accessible to them than their own governments. And after time, history has proven them correct.

Each of the years 1975, 1980, 1985 saw a world conference organized as part of the United Nations Decade for Women, and each took a step forward in the recognition of the role of women in development. In 1975 the theme was enshrined in the adopted

Declaration of Mexico on the Equality of Women and Their Contribution to Development and Peace, and the World Plan of Action for the Implementation of the Objectives of the International Women's Year. In December 1975, when the General Assembly adopted the Declaration and Plan of Action and declared the period 1976 to 1985 the United Nations Decade for Women, *development* became one of the priority themes along with *equality* and *peace.*

The World Conference on women at Copenhagen in 1980 was a further step forward for women, toward the implementation of a new international economic order. The objective was to give women the opportunity to participate on equal terms with men in development, recognizing that they already, indeed, have played a major role, and at the same time affording them the means to fulfill their role rightfully. That objective was considered to be the path to achieving a more just and also more durable and rapid international development. At the same conference, a binding international instrument—the Convention on the Elimination of Discrimination against Women—was adopted and ratified by many member states and entered into force in September 1981.

The Nairobi conference was a milestone for women. Coming at the end of the United Nations Decade for Women and at the fortieth anniversary of the organization, the Nairobi Foward-Looking Strategies for the Advancement of Women provided a detailed diagnosis of the obstacles, faced by women, to achieving the objectives of Equality, Development, and Peace. Could such a thorough diagnosis be achieved today? Development was still one of the priority themes. The trilogy of "equality, development, and peace" was reaffirmed and again formed the background against which goals were set for the advancement of women up to the year 2000.

Each theme is both the means and the end. Their close interdependence is reaffirmed: development is possible only if there is equality between men and women, and conversely, there cannot be de facto equality between men and women without development. Peace, as a condition for the achievement of equality, implies a certain level of development, since the word *peace* must be understood not only as the absence of war or conflict but also as the enjoyment of economic and social rights. In addition, three subthemes were defined as being the essential foundations on which equality, peace, and development should be built: employment, health, and education.

The strategies constituted a basis for an appraisal of how much progress had been achieved in the previous ten years. How far had we come in this time? The first review and appraisal in 1990 stated that "after five years of implementation one third of the time set for achieving the objectives having elapsed, obstacles remain. Although continued efforts of women throughout the world have begun to have an effect at the grass-roots level, this success is largely invisible." It concluded that the pace of implementation must be improved in the crucial last decade of the twentieth century. There is now more evidence of improvement, especially in terms of the expression of legal rights and in the principle of equal access to education in much of the world.

The most dramatic change—but one of the least recognized—has been the massive incorporation of women into the labor forces of the countries having the highest growth, as workers, as entry-level administrators, and as micro-, small-, and medium-scale entrepreneurs. In a very real sense, therefore, it is women who have driven global recovery since 1985.

There have now been twenty-eight women elected as head of state or government, most of them in the last ten years. In the UN system, there are four women heads of agencies, and the percentage of women in senior and middle management of the organizations of the UN has doubled since 1985.

This is all good news, but it must be taken in perspective. Women still lack equal access to education and health in the most populous and poorest regions of the world. Women in the workplace hold the most precarious and least well paid jobs. Women are the first victims of unemployment in both developed and developing countries; they are also the majority among the poor, often as single heads of family. There are only a few countries in which about 30 percent of government decision makers are women, and in the United Nations, the doubling of the number of women in senior management posts only means that, on average, 8.4 percent of senior managers are women.

Where are we, then, in 1995? I would say that women are poised ready to make the difference that we all believed they could make, if only they could participate on the equal basis that is specified in the charter. Yes, today there are more women in decision-making positions, and among the younger women leaving universities there is parity with the young men. There is a consciousness among most

women and many men that equality is not only desirable for society, but it can also be achieved.

However, we have still a long way to go. The world has completely changed in the last decade. It is true that we have progressed in many ways, but in the face of the difficult implementation of the Forward-Looking Strategies, we have had to contend with a kind of lassitude coming after the exhilaration felt in its aftermath. Many people—women and men alike, but perhaps especially men—would like to turn the advancement of women over to the forces of history and the "magic of the marketplace"; to let natural processes work in the hopes that, by and by, equality will be achieved. We know differently. When one starts with a situation of inequality, all the market does is perpetuate this inequality. To overcome inequality, one must consciously act to do so. This thought is behind our tasks today and defines our role:

- We must keep up the pressure. We cannot allow the issue of advancement of women to disappear. We cannot let our sisters, especially those already benefiting from the fruits of these changes, to become complacent. Also, it is essential to enlist more men in the struggle.

- We must continue the learning process. We must explore the nature of our societies and economies to see and understand the real effect of economic and other policies not only on women but on all members of society and at all levels. We must apply the power of analysis to use this understanding as a vehicle for positive change.

- We must act to accelerate the processes of change. We must formulate new policies for affirmative action, as well as for a just society where dignity, freedom, and well being are not only the benefit of the few but apply to all members of society.

I am convinced that with will and determination, these are the ways to make the necessary difference. And we sincerely believe these ways are worth the effort of trying.

Nonetheless, we must not be complacent either. There are many dark trends on the horizon. We are now witnessing a backlash against the advancement of women in different types of societies and in many countries. Whether this is expressed through terror and

violence (and even rape) against women by religious fundamentalists, or extremists of different kinds, who oppose equality between men and women and the opportunity of free choice for women, or by those opposing any affirmative action not only in United Nations' fora but also in the countries themselves. Resistance to equality is becoming more serious and beginning to be felt in the watering down of concepts and principles of equality. While such opposition tends to take the form of quests for "identity," "tradition," and "stability of the family," it is really an expression of fear of sharing power and responsibility on an equal basis. But why? This is in clear violation of human rights and specifically of *women's* rights. Underlying this fear is the sentiment that if women gain power men will lose it. It is this last and most dangerous assumption that we must address in order to eliminate this fear. We believe—and we are convinced—that men and women together, believing in democracy and freedom of choice, can work together to create a better world.

As we stand at the threshold of the twenty-first century and look forward, I would like to pose the question again: What difference should it make that women share power and responsibility equally with men? What new horizons will it bring?

Let me make several premises very clear. I do not believe that having more women in power would necessarily mean a more peaceful, gentler world. I do not believe that virtue rests inevitably with one sex rather than the other. On the contrary, I do believe that women, by virtue of their life experiences, have necessarily a different perspective on our present problems and their solutions than do men. I believe that applying these perspectives can change, dramatically and qualitatively, the world as we know it today. What are some of these differences of perspective?

1. Women have never seen relations between people as a game, where if one party gains the other loses. We believe, more importantly, that when one party gains, everyone else should gain too. Our mode of approach to life is cooperative, not competitive.

2. We are as concerned with the future as we are with the present. The world we leave for our children is as important as the world we live in today. It is not a matter of chance that women are more concerned with the environment than men.

3. We believe, instinctively, in democracy, in shared responsibility and agreed choices, based on a search for consensus. It is no surprise that women's meetings reach agreement faster and more smoothly than those where only men are present. Nairobi is the best example.

4. We women recognize and value diversity. Our lives teach us to be more tolerant. We know that women are not homogeneous but that there is strength in our differences—especially if we can maintain, at the core, a sense of what binds us together.

Imagine, if you will, what the world of the twenty-first century could be like if these perspectives were brought to bear: a world of diversity, cooperation, and consensus, where choices are made based on both their present and future consequences. The policy choices in areas of peace and development would be more effective. While it will never be a perfect world, it would certainly be kinder, more tolerant and peaceful, and it would be a world in which equality sets the standard.

Beijing should be our chance to confirm women's rights acquired and expressed in Nairobi, and as contained in the Convention on the Elimination of All Forms of Discrimination against Women. Beijing must be the step forward to the world we will give to our children and our grandchildren, the world of the twenty-first century. A world of freedom, equality, and peace.

—Director of the Division for Economic Cooperation among
Developing Countries and Special Programmes
(Africa, Palestine, Poverty Alleviation)

11

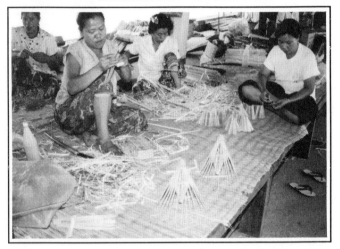

The making of umbrella, Chiang Mai.

S tatement by the Director-General of UNIDO

Mauricio de Maria y Campos

Fifty years ago, the founding members of the United Nations solemnly adopted the United Nations Charter. Some historical documents are so well written that they are worth quoting occasionally, and certainly every fifty years. The UN Charter says: "We the peoples of the United Nations determined to reaffirm faith in fundamental human rights, in the dignity and worth of the human person, in the equal rights of men and women and of nations large and small, and to promote social progress and better standards of life in larger freedom" and, for these ends, "to employ international machinery for the promotion of the economic and social advancement of all peoples."

The objectives of the United Nations Charter remain as valid today as they were in 1945 and remind us that the achievement of development, peace, and human rights is a continuous and unrelenting struggle. Women have always been central to this process and have often borne more than their share of the sufferings. It is only since 1975, however, with the First World Conference on Women and the proclamation of the United Nations Decade for Women, that women have been increasingly recognized, not only as beneficiaries of the development and technical assistance efforts, but as full actors and key partners in the development process.

The director-general's statement was delivered by Reginald Van Raalte, Managing Director, Division of Administration, UNIDO.

Before then, women had been largely absent from debates on development policy, with discussion on social cleavages being focused mainly on income and class. In the 1970s, for the first time, efforts were made to link women's issues to development. This gave rise to what has become known as the Women in Development (WID) approach, which firmly placed women on the development agenda. All agencies of the UN system have since adopted this concept, which usually combines the mainstreaming of women's issues into programs, projects, and research activities together with activities specifically targeting women. This is, indeed, the view that has been followed by UNIDO since the establishment of the Integration of Women in Industrial Development Unit in 1976.

The shift from a WID approach to a Gender in Development (GID) approach began in the 1980s. This broader concept seeks to examine the roles of both men and women and the relations between them, their differential access to and control over resources, and their different needs. It also implies the recognition that the lives of both men and women are multidimensional and have to be perceived and addressed as such in policy and planning terms. This approach has been or is increasingly being adopted by various agencies of the UN system.

The Nairobi Forward-Looking Strategies for the Advancement of Women, adopted by the Third World Conference on Women in Nairobi in 1985, remain critical for the promotion and the advancement of women today. Important progress has been made, in such fields as primary education for example, but many obstacles are to be eliminated to ensure a full and complete implementation of the Nairobi strategies. These obstacles are well known and range from gender discrimination and cultural barriers to women's conspicuous absence at the policy- and decision-making levels, violence against women, and continued violations of women's rights.

These obstacles are currently compounded by the dramatic changes in the world social and economic order, the globalization of markets, and the liberalization of capital and technological flows. The impact of these changes on the status of women is undeniable: there is an increased burden of poverty upon the already poor segments of the population, many of whom are women and children, and migration flows have increased, prompted by economic recession, restructuring, civil wars, and ethnic violence. The world is not at peace, and

women, particularly in developing countries, continue to suffer disproportionately from discriminatory practices at home and in the workplace, with little or no access to the benefits of education and training, health care, and employment.

All these issues have been the subject of new or renewed analysis, both at the global and regional levels, in preparation for the Fourth World Conference on Women in Beijing. Healthy and sometimes hot debates have taken place with govemment representatives and nongovernmental organizations. Each region of the world has, last year, adopted its own platform for action, highlighting regional specificities and priorities for action. The Global Platform for Action to be adopted in September in Beijing should bring about, for each of the areas of concern, a set of strategic objectives and measures to ensure effective promotion and advancement of women at all levels and at all stages of development of their societies.

The United Nations System has an obvious and special role to play in which all of us, women and men, must take our part. The United Nations is an extraordinary force in mobilizing minds and means for a cause; through its advocacy role and its mandate, the UN must be the prime mover of ideas and universal values; through its financial resources and technical assistance programs, the UN brings development forward. In fact, the United Nations should set an example for others. Unfortunately, in the UN system itself the promotion and advancement of women still leaves a lot to be desired.

The case of the advancement of women in the economies in transition is worth a special mention. Whereas women in these countries were for several decades considered de jure, if not always de facto, to be on an equal footing with men and were provided safeguards to that effect, their status is now being eroded, and traditional gender stereotypes, long thought to have disappeared, are now resurfacing. Women in those countries represent, on average, half of the labor force and in most countries possess education equal to or better than those of men. At the same time, informal norms and behavior put women at a disadvantage both in the workplace and within the family. The level of women's education does not match the low-skilled positions they predominantly occupy, and they are an easy target for employment cuts. I am therefore very happy to see that one of the panels will focus its discussions on this phenomenon.

Several panel discussions will address the role of women in the economy. In UNIDO we believe that without economic growth and sustainable industrial development, no social progress can be achieved in a sustained manner. Employment opportunities must be created for all. Human resource development is a key to offer women and men more options for their development and that of their communities and societies in general. Technological advances and progress, although sometimes viewed negatively in some quarters, also carry responses and solutions to alleviate poverty and drudgery and to improve the quality of life for all.

As international or national civil servants, a heavy responsibility has been bestowed upon us. It is our common concern, and it is a commitment that we all very much feel and share. Beijing should be viewed, not as yet another "starting point," but as a conference of real commitments, both political and financial, to bring about equality in all spheres of life, peace, and development for all.

-

12

A woman making hand-made paper.

GENDER IN DEVELOPMENT
A Critical Issue for
Sustainable Development
Rosina Wiltshire

Let us begin by defining the "what" of gender in sustainable development. It is my experience, even with those people who are fully supportive of Gender in Development, that sometimes we use the concepts of *gender* and *women* interchangeably. I define gender as the differential roles of men and women, their responsibilities, attitudes, perspectives, knowledge bases, and access to resources and decision making, as well as their differential needs and the implications of all of these. Gender is societally defined, and its manifestations and implications differ across societies and cultures. Gender therefore requires a comparative focus on women and men and cannot be analyzed or programmed purely from the perspective of women. Gender, in other words, provides a balanced lens through which one views, analyzes, and evaluates phenomena and programs. It requires an ongoing focus on both substance and process.

What are the priorities of gender in an issue with specific issues and impacts, and how and by whom are they being decided? I want to emphasize the substance and process because it is often assumed that if you are programming for women, you are doing gender programming even when the decision makers and your programmers are 90 percent male. The lenses, the priorities, and the processes are critical to the substance, and I will elaborate on that as I go on.

What is sustainable development? I define it succinctly as development that promotes human well-being and human dignity while

regenerating and protecting the natural resource base so that the issues of empowerment and equity are central to development, which cannot be equated with economic growth per se.

What are some of the most pressing development issues that we face? Women make up more than half of the world's population, and of the estimated 1.3 billion people of living in absolute poverty, more than 70 percent are women. Women are more likely to be poor in the industrialized world as well. Women contributed, according to the UNDP 1995 Human Development Report, *two*-thirds of the productive work now made invisible by the statistics on development. In turn, our measurement of productivity and wealth now makes invisible most of the wealth creation in which women are involved. Even though in many regions of the world 30 percent of the household heads are women, and even where they may not be heads, women's income and production are significant to family, food security, and well-being, women are systematically paid less than men for the same and similar jobs and their nonmonetized work ignored. Through analysis and the collection of data, we can clearly recognize the subordination of women and the need for a specific focus on women when doing gender analysis. Comparative analysis indicates where we need to focus on women and men in programming and policy focus.

Why are we looking at gender, and why is gender essential to sustainable development? Three key issues are equity and social justice, efficiency, and effectiveness. A spurious either/or dichotomy is often drawn between equity and efficiency, and I was pleased that the keynote speaker this morning said that women's perception of the world is not zero sum. The fact is, the world is not zero sum, and these three important dimensions are intricately interconnected. The three are in fact integrated objectives of mainstreaming gender. It is not possible to address society's needs at any level while ignoring the perspectives, priorities, and knowledge of more than half of the world's population. Men and women make up two inextricable halves of society whose behavior, relationships, and attitudes are structured by gender, ignoring these is to ignore perhaps the most fundamental factor guiding human behavior and outcomes. Gender cuts across race, class, ethnicity, religion, and rural/urban dichotomies and is therefore, essential for our understanding of sustainable development. It is essential for our ability to make a difference to sustainable development.

One example of the link between gender and development comes from Franie Ginwala in South Africa. Even though I have been involved in gender analysis and mainstreaming and research for years, her "seat belt" example brought home to me very clearly how fundamental gender is to the issue of development and sustainability. South Africans, in their attempt to transform their country into a nonracist and nonsexist society, put a lot of emphasis on bringing a gender perspective to science and technology. This has been directed to the production of arms and industry during the apartheid regime. In one of their meetings the head of the science and technology unit said, "I cannot understand what gender has to do with science and technology because gender is usually defined as a social issue, not an issue that cuts across all sectors and all disciplines." Franie Ginwala, who is now the First Speaker of the House in South Africa said she was really pleased when an African woman got up from the back of the room and said, "when seat belts are made for people with breasts, I will tell you what gender has to do with science and technology." I was struck by the example because I know that even though I don't have big breasts, I have struggled with seat belts for a long time trying to make them comfortable, and the gender aspect had never hit home so clearly. When I was pregnant the same phenomenon was even more emphasized. One never thinks when one looks at seat belts if how gender applies to their design. If a more gender-sensitive design were achieved, seat belts would be more efficient because pregnant women, and women in general, would be less likely to discard them as too uncomfortable and in some cases unusable. This example brings home dramatically the essential linkage of gender to social justice and equity, effectiveness and efficiency.

I move from the "what" to the "how" of sustainability. Mainstreaming is an essential of the "how," but mainstreaming does not mean that we ignore gender-specific, or women-specific activity. Mainstreaming means that a gender-balanced perspective must inform program and project priorities, as well as their design, monitoring, and evaluation, in every facet of organizational activity. Mainstreaming involves the promotion of gender balance in decision making at all levels so that policy, program, and project priorities reflect a gender-balanced perspective and knowledge base.

Here is where the women-specific dimension becomes clear. Because of women's subordinate status and unequal access to resources and

decision making, a specific focus on empowerment of women and gender equity is required along with gender mainstreaming. It is not good enough to say that, because we are mainstreaming, projects that focus specifically on women are not relevant. Because women are invisible in most fora of decision making and do not have the same access to resources, to have a gender-balanced perspective informing organizational priorities we must actively promote equal participation in every level of decision making. It is not good enough—as in most UN organizations where very few women are at the top decision-making level—for predominately male groups to set priorities on development and assume that those are going to make for sustainable development because they purport to focus on women or integrate gender concerns.

For gender to be fully mainstreamed, women's perspective's have to inform those policy priorities, and that has to go right down the line to the feed level, where women are defining, monitoring and designing the priorities of development as they affect them. Within gender mainstreaming, gender analysis indicates where the specific focus on women needs to be and where the specific focus on men may be necessary. Mainstreaming Gender in Development just means that any institution is thus dealing with substantive issues as well as process issues across the board, upstream and downstream.

Research has demonstrated that when the proportion of women making the decisions on development reaches 30 percent, a whole different set of priorities emerge. They tend to be more human centered, more socially focused. They tend to relate to equity, and the decisions are also more likely to be consensual than conflictual. Such decision making is central to the task of guiding industrial policy and technology policy toward sustainability.

Gender in Development is a process and a perspective that makes for a different way of measuring reality and looking at our reality, a different way of seeing what is productive and what is not productive. It is a matter of valuing the elements of our human activity that involve nurturing and care, that involve the glue and substance of sustainability and peace—elements that are now not at all valued and now not measured because women are locked out of the decision-making process on what constitutes sustainable development, what constitutes productivity, what constitutes wealth, what constitutes power.

I wish suggest the following two recommendations:

1. Organizations should have an explicit policy for promoting gender equity in decision making, including the highest levels of decision making, both internally and in their policy and programming. This applies to organizations across the board, including NGOs. Mainstreaming cannot take place in a context where the leadership at every level is predominately male. There should be explicit targets and accountability measures for promoting gender equity and equality within organizations.

2. All policies, programs, and projects must be evaluated on the basis of whether men and women were equally involved in their design, monitoring, and implementation, and evaluated as well on the extent to which they enhance gender equity and equality (equality of access, equity in resource distribution). Gender capacity-building should take place within the organizations. Capacity building is usually set as an objective with regard to clients and recipients of development programming and often is not seen as being necessary within an organization, particularly at the higher levels. Although the UN organizations have provided the fora for the promotion of gender issues, the UN paradoxically brings together the multiple chauvenisms of all the worlds. The process has to begin within, and much of the work has to start from the top if we are to make Gender in Development a sustainable process.

> —*Manager, Gender in Development,*
> *United Nations Development Program*

13

A peruvian woman carries a lamb while driving her livestock home for the night. Photo by I. de Borhegyi.

*W*OMEN AND INFORMATION
TECHNOLOGY
Opportunities and Challenges:
A Social Issue

Konrad Fialkowski

Information technology is driving us toward a digital world. What we see now is the beginning of a long road that changes many if not all aspects of our lives, including our workplace, leisure, creativity, and family life. This technology provides important challenges for society to cope with and creates new opportunities for women to strengthen their role in society. The following quotation from *I & T Magazine* shows us the digital world as it will be, perhaps in the first decade of the twenty-first century:

> Homes and offices are now connected at minimal cost to thousands of powerful and easy-to-use digital services. The precursor of them all was the French Minitel at the end of the twentieth century. These services cover about all of human activities ranging from working at home—independently or for a company—to the distribution of music, movies, custom-made news or cooking recipes directly displayed in the kitchen.

> The quantity and the richness of the resources made available to almost everybody has given rise to new sources of revenue rewarding the creative intellectual production of all individuals. For example, an attractive or interesting photograph (digital of course) can be loaded from your home in specialised databases served by information agencies. Having specified from your terminal the owner of the information as well as the fees attached to future use of your creation, you will be automatically paid should anyone find

your creation useful for his personal or professional use. The information will be automatically deleted from the database or returned to you if after a certain period of time it has not been accessed by potential users. Indeed, a new profession has been created just for tracking information potentially interesting for certain organisations, for example news agencies.

On the other hand, you can pay for any information or services you use with a personalised "smart" copyright/payment card. This card is used as an electronic debit card for general purpose payments but also has particular features specific to certain applications. For copyright operations, payments are made instantly on-line when you are connected to a server. For off-line operations, payments are debited from a prepaid amount loaded in your card and the information to whom the payment has to be relayed—(copyright owners and service providers)—is transmitted each time you renew the prepaid amount stored in it or whatever you make an on-line transaction.

One of the most popular services is to get well-known paintings of famous artists displayed on large extra-flat LCD screens, with colorimetric correction features, hung on your walls; usage fees could be just for one evening or for a whole year, and the image disappears automatically at the end of the rental period.

Exciting as these prospects may be, at least some of them seem to belong to the somewhat distant future.

Looking at the closer future between the present and the end of this century, however, we already can see some applications could fundamentally change the office environment, also within the UN system, from the one we are accustomed to.

Let us consider, for example, the already existing "talking dictation computer," which, although its use is not yet widespread, can produce an electronic or, if needed, printed copy of a dictation. How many relatively low-skilled jobs will be eliminated by this device? This machine could certainly be considered an example of the labor-endangering phenomenon that has accompanied the development of information technology almost from its advent. Such a computer may, however, be regarded differently—as an example of the new information environment in which change is the essence of reality. This environment brings a new element to our lives, one that has been absent in all past generations of humankind and that is, to some extent, psychologically difficult for the individual to cope with.

This problem results from the fact that human beings are most apt to learn in their youth. In the past, skills acquired in one's youth sufficed

to cope with the techno-social environment throughout one's whole life. Now change is very fast, and those born more than half a century ago live in a world essentially different, not only technically but also socially, from the one in which they grew up. In many cases this has resulted in difficult adaptation to the new working and social environment, sometimes leading even to alienation. One should realize, however, that from our generation on this will continue, and we, as well as the next generation, must learn to live in such a dynamically changing world.

For women, however, the situation is easier than for men. Anthropologists tell us that women are better adapted than men for coping with complicated social environments. Therefore, their chances of adapting to the changes brought on our lives by advances in information technology are more favorable.

To contend with these circumstances, however, an awareness must be created that these constant changes are inevitable. The first conclusion is obvious. The rapidly changing work environment and social world generally require a lifelong learning process for everyone.

Information technology not only invokes the pressure for permanent learning but also provides the means to implement it. The use of satellite as well as terrestrial communication lines for long-distance learning, broadband telematics for interactive video, video conferencing for professional training, and the INTERNET as a global system for the virtual university are just some of the means offered.

The vital task for organizations and institutions, in our case the UN system, is to make these new educational means easily available as soon as possible. In our competitive world, those who appropriate these means early will have a tremendous advantage over the latecomer. By making information technology available to women, independent of their current professional position within the UN system, we can provide them with opportunities to keep up with development's needed not only in their present work but also in areas that are now emerging (e.g., the virtual library) and will continue to materialize in future.

Therefore, new information technology should not be regarded as a threat to the established labor modes but rather as an opportunity for women to jump into an emerging labor niche, providing a chance to master skills now in short supply on the labor market, and thus ensconce themselves as highly qualified and singular specialists.

—Technology Development Section/Technology Service

14

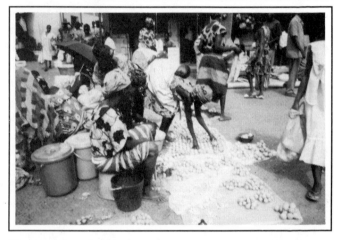

Women selling Londolfia Asulis and cashew at market, Guinea Bissau. FAO/R. Faidutti.

*I*MPROVING THE STATUS OF WOMEN
IN THE UNITED NATIONS SYSTEM

Chafika Meslem

Nearly fifty years ago, Eleanor Roosevelt presented an open letter to the first session of the first General Assembly of the United Nations. Drafted by women representatives to the General Assembly, the letter included the following words:

> We are gratified that 17 women delegates and advisers, representing 11 Member States, are taking part at the beginning of this new phase of international effort. We hope that their participation in the work of the United Nations may grow and may increase in insight and skill. To this end we call on the governments of the world to encourage women everywhere to take a more active part in national and international affairs, and on women who are conscious of their opportunities to come forward and share in the work of peace.

Article 8 of the United Nations Charter states that "the United Nations shall place no restrictions on the eligibility of men and women to participate in any capacity and under conditions of equality in its principal and subsidiary organs."

It is clear that in the years that have elapsed, the United Nations has failed to live up to Article 8. The recruitment and promotion of women in the United Nations has lagged behind the expectations implicit in the charter. However, the resolutions frequently adopted by the General Assembly, as well as the plan and action programs coming out of the Mexico and Copenhagen international conferences and the Nairobi Forward-Looking Strategies (NFLS) recalled with insistence the need to improve recruitment procedures for women in the secretariat and to promote them to higher positions.

The first focal point for women was created in the early 1980s but did not attain worthwhile results. Neither the UN administration nor even less, the member governments showed any sense of urgency in putting into effect the resolutions favoring the recruitment of women. In practice it was found that most governments presented only male candidates. It was only in 1990, at the time of the first review and appraisal of the NFLS, that the Committee on the Status of Women began to establish precise targets.

In March 1993 the present secretary-general issued encouraging instructions on "special measures to improve the status of women in the secretariat." His goal was to bring the gender balance in policy-level positions as close to 50–50 as possible by the fiftieth anniversary of the United Nations.

This year we are celebrating the fiftieth anniversary of the United Nations. All of you here today occupy high positions within your governments and in the United Nations system. Seeing this large gathering, one might even have the impression that we have attained the desired balance! Yet we all know that our organization remains far from achieving the right equilibrium.

On the occasion of its forty-eighth session, the General Assembly adopted resolution 48/106, which emphasizes the importance of closing the gap between men and women at senior policy levels and in decision-making posts, as well as improving the presence of women from unrepresented and underrepresented countries and regions. Reaffirming his personal commitment and backed by this resolution, the secretary-general presented his Strategic Plan of Action for the Improvement of the Status of Women in the Secretariat, 1995–2000, to the General Assembly at its forty-ninth session, in document A/49/587. The plan was endorsed by the General Assembly through its resolution 49/222, on the recommendation of both the Third and Fifth Committees.

The Strategic Plan of Action sets three targets: an overall level of 35 percent women by the end of 1995; at the senior level, 25 percent women before 1997; and overall gender equality by the year 2000. The Plan of Action is no doubt bold in its aim of achieving in five years what could not be done in half a century; but it has brought the status of women to the forefront of Office of Human Resources Management (OHRM) priorities. Indeed, the objectives of the Strategic Plan have been

translated into a blueprint for action that is fully integrated into the succession plan of OHRM concerning the number of vacancies that are expected to occur between 1995 and the year 2000. Such forward-planning entails the establishment of specific annual targets and percentages for all posts subject to geographical distribution, with the aim of filling a larger proportion of these posts with women.

As matters currently stand, nearly 35 percent of professional posts subject to geographical distribution are held by women. An almost equal number of men and women are currently being promoted by the appointment and promotion bodies. Moreover, the UN has nearly doubled the rate of appointments and promotions of women to senior positions over the past five years. These steps to bring more women into decision-making roles in the UN are important not only for equity reasons but also to reflect more adequately women's experience and concerns in all aspects of the organization's work. There is no room for complacency, however. If the level of representation of women in the UN continues to increase at the 1.8 percent per year pace experienced during the past five years, gender equality will not be reached until the year 2008.

As urged by the Administrative Committee on Coordination (ACC) at its first regular session in 1995, continuing efforts must be made to remove all obstacles to the recruitment, retention, promotion, and mobility of women, and to create a supportive environment for women's work. Executive heads should hold senior managers accountable for the implementation of these policies at the level at which the targets have been set. By proposing and supporting qualified women candidates, member states could play a critical role in facilitating the UN's efforts to achieve the gender-balanced organization that they have called for.

Complimentary and specific measures to facilitate the recruitment of qualified women must be devised on an urgent basis. The ACC, for example, has proposed that the United Nations organizations ought to be requested to draw upon their field presences to prospect for suitable women candidates in all disciplines. OHRM should conduct recruitment missions, advertise broadly, and where appropriate, cooperate with executive search firms in order to upgrade the rosters of external women candidates. Efforts should be intensified to recruit qualified women to posts subject to geographical distribution, through

the national competitive examinations held by the United Nations and the identification of highly qualified women who have served as consultants to the UN. I am convinced that, given the will that has been shown to improve the gender balance in the organization, ways will be found to reach the established targets.

—*Director, Division for Economic Cooperation among*
Developing Countries and Special Programmes
(Africa, Palestine, Poverty Alleviation), UNCTD

WOMEN PROFESSIONAL STAFF IN
THE UNITED NATIONS SYSTEM

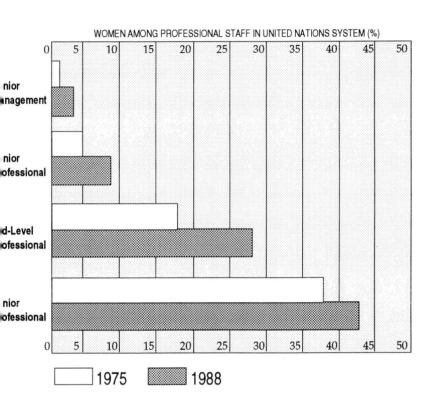

WOMEN AMONG PROFESSIONAL STAFF IN UNITED NATIONS SYSTEM (%)

1975　1988

Note: Excludes World Bank and International Monetary Fund, since their system of grades differs
from that of the United Nations common system of salaries and allowances.

Sources: Compiled from 'Composition of the Secretariat', annual reports of the
Secretary-General to the General Assembly.

15

Woman at the library in Sudan.

ENTREPENEURSHIP DEVELOPMENT FOR WOMEN

Camillo Antonio

I would like to acknowledge the presence of several colleagues here who have worked with me in designing, implementing, and evaluating entrepreneurship development programs in the 1980s, which led us to related work in privatization measures at the end of the 1980s and at the beginning of the 1990s. I refer to Ms. Gregor as a sparring partner. We were later joined by Rick Kennedy of the Hawaii Entrepreneurship Development Institute. M. A. Martin has been a colleague who shared our ideas and who helped us to develop entrepreneurship programs in Africa. She is now speeding us up in her role as integrator of women's issues and programs. Ms. Chambalu, her predecessor, whom I see in the audience, also helped in developing and piloting some test programs in the food sector in southern Africa. I mention that in particular to highlight the importance of that team effort and the presence of some informational materials as a basis for furthering modular programs in entrepreneurship development. In this respect, I would like to emphasize the difference between role-modeling for entrepreneurship and role-modeling for management.

This is important because, when we talk about problems of access to credit schemes—preferential loans, for instance—or the role of development and commercial banks in facilitating investment flows, that's part of the globalization process. Most of the problems come in where our lenders have not yet considered the entrepreneurial

aspects of a loan other than the traditional method of questioning the management issues related to the loan as a way of ensuring repayment. That is to say, the loans that are being appraised by most of our commercial officers are viewed mainly, if not purely, from a man's hierarchical and economic world, as though one were merely talking about husbanding of resources or managing what is already in place. When women come up with their own projects, in contrast, those projects may involve innovative ideas and untried skills. There is a risk issue that is not easy to perceive and to administer on the part of loan officers or the people who are transferring technologies to enable women to start an entrepreneurial venture.

I wish therefore to plead to all of those who are setting up, designing, or furthering entrepreneurship development programs not to be waylaid by the special skills that we are trying to focus upon and develop when we are talking about the woman as an entrepreneur, as opposed to the woman as a manager who might then offer herself to corporations. Part of the globalization process is the breakdown of structures, which may pose a threat that many mergers coming up as strategic alliances among the big groups that could function like monopolies. If women could be furthered to see to it that there is a counter opposition to this alarming trend, by being encouraged to form strategic alliances optimizing the efforts of small enterprises. The breakdown of structures is a positive aspect of the evolution of both society and individuals in that it makes possible the greater independence needed for taking initiatives and managing the accompanying risks. This is what we are seeking in empowering women to have control not only of their resources, meager as they are and difficult as they are to have access to, but also of their time. The countertrend toward big conglomerations raises difficulties for women who have come at the beginning of the 1990s into what we call the new opportunity for SMEs: a borderless enterprise. The cross-border transactions found in so-called interesting growth triangles, along with deregulated activities and free trade flows, may prove to be detrimental in subtle ways as we enter the complex world of the twenty-first century.

Human resources cannot be too heavily emphasized here. Of course it is true, as Ms. Martinez says, that a country ought to have a base and therefore agricultural development is important, but that

is not necessarily the case for every country! Consider the tigers—Singapore, Hong Kong Japan, South Korea—who did not have an agricultural base and who in fact developed from a nonresource position. The Philippines in the 1960s had a strong agricultural base, and also some structural problems: the haciendas were breaking down, for instance. Men who ruled the haciendas were still there. But we had a good agricultural base with a lot of value-added products, which we probably should be espousing when we talk about agricultural development. Industry is indeed a motor for a lot of entrepreneurial projects, programs, and activities. It is industry that has given the products and additional services that have allowed us to address some of the things that still are problematic but have already been addressed with industrial surpluses. Thus poverty alleviation, the integration of women, productivity improvement, and other social themes have been attended to, albeit partly, by increases in stable incomes, the generation of new jobs, and foreign exchange earnings.

Finally, I'd like to put an emphasis on education: not on formal education, but on continuing education and the kinds of changes that would help us get to the root of the problem of getting into a man's world today. One of the biggest problems, I feel, is when we lock ourselves into a futile combat even in boardrooms or in meeting rooms and get into logical systems. Logical systems are a strong instrument of a man's economic and hierarchical world. E. De Bona's recommendations of the 1960s, to look at other forms of thinking and other forms of gathering information, have not yet seeped into our educational systems. Perception, for instance, as a way of opening up sources of information, is an entirely different method and has entirely different consequences from logical systems. It is difficult to introduce this system in formal situations, but we might be able to introduce this better in informal situations.

We should not look at entrepreneurship development as a monolithic structure, nor should we think that women's possibilities for entrepreneurship should be furthered only in the corporate structure. In today's global context, women can tap into a great many economic opportunities, and we should see to it that chances in microenterprises are furthered as well. We should look at these not in exclusive terms but rather in inclusive terms, and we should consider women's opportunities when we look at various target

groups. When targeting women, we should be able to distinguish between preparatory aspects and other conditions in which women might be able to move from one stage of entrepreneurship to another. Facilitative structures should further confidence in women and enable them to assert themselves in their various business roles, as owners, managers, negotiators, and marketing strategists. Intervention might also be needed in working out a schedule with family members so that the female-led entrepreneurial venture is something they wish to see working and to which they would give their support. The sensitivities involved in different cultural contexts call for an entirely different technique. Expanding or diversifying the female-led enterprise calls for other types of skills that have to be honed. Business planning and negotiation skills, for instance, are crucial to business expansion. Many enterprises fail because they diversify and grow too quickly. This again is something that is not understood well enough by loan givers and private investors as well as people who offer technologies. Marketing is an important aspect of growth-oriented enterprises, especially for export. Here imaging of the product is very important. In this regard I have two suggestions to make:

First, imaging is a skill in which women are better prepared and better equipped than men, because soft skills in communication are especially called for. However, women should look at the possibilities of multimedia technology to support what they already have or what nature has given them.

Secondly, information technology and multimedia can seem scary and expensive. Both have prejudicial aspects, which should be dealt with in entrepreneurship programs. First of all, it is not true that they are very expensive, and secondly, there are ways in which one should be able to face a computer without turning oneself into a machine. This is the kind of objection that we get from our women entrepreneurs. For instance, in Malaysia, as part of the local ethnic population groups that were furthered to go into entrepreneurship programs, women were afraid of computer technologies because, they said, "We do not want to become robots."

—Acting Head, Human Resource Development Branch, UNIDO

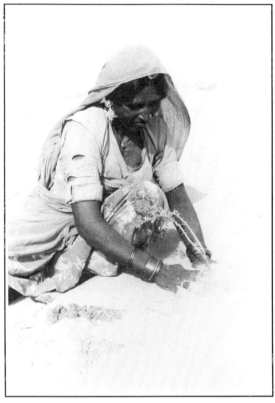

Indian woman planting a tree. WFP Photo/Paul Mitchell.

ℱEMALE LITERACY
AND EDUCATION
Promoting Peace, Human Rights, and Democracy
Kaisa Savolainen

Certain prerequisites must be satistied for women to be empowered, enabling them to enter the labor market on equal terms with men. The most important is a good educational background, accompanied with the requisite experience in responsible positions. If preference is given to men from the start, then in situations of nomination, men are more qualified because they have a broader experience.

In many parts of the developing world, unequal access to education, is still a problem that prevents women from obtaining a solid education. Illiteracy is disproportionately high among adult women: two-thirds of the world's illiterates are women. So-called equal access to education, where it has been achieved, does not necessarily mean an equal distribution of girls and boys in the different fields of education. On the contrary. In technical and vocational education, women and girls enter fields that are traditionally occupied by women (such as teaching, nursing, sales, etc.), while men are for the most part in industrial production, engineering, and agriculture. It is also a well-known fact that salaries in the occupational fields dominated by women tend to be lower than in those fields dominated by men. Everybody can draw conclusions as to how this phenomenon reflects on the value systems of societies. Therefore, women's literacy and the provision of life-long learning opportunities for women

should be a high priority in all developmental programs of govern-
ments, donors, and international organizations.

An important aspect of education is the content and relevance of
educational materials and media. In this context, I wish to raise three
issues: (1) the educational process; (2) education for peace, human
rights, and democracy; and (3) values of education.

The Educational Process

The educational process can perpetuate existing inequalities by
reinforcing certain perceptions and stereotypes in curricula and
textbooks. Studies of basic textbooks show that they describe women
in a limited number of roles in working life and society. Moreover,
research indicates that teachers treat girls differently from boys in
the classroom, and this is not necessarily done consciously. When
these stereotypes are also reflected in the mass media, they become
percieved as more or less "natural" phenomena, and nobody consid-
ers that they lead to de facto discrimination. It is thus no accident that,
in general, the majority of teaching staff is female, while leadership
and policy-making positions are occupied by men.

Education for Peace, Human Rights, and Democracy

The educational system, should promote peace, the preservation of
human rights, and democracy as part of the process toward empow-
ering women. Women always suffer from the phenomena that
threaten peace and democracy. Violence, racism, xenophobia, ag-
gressive nationalism and violations of human rights through reli-
gious intolerance or terrorism all have a negative effect on women's
status. Poverty is on the increase within and among countries,
paving the way for interpersonal violence in cities and communities,
even in schools and families.

Family life, in its multiple and diverse forms, is the child's first and
most influential learning environment. Therefore, education on
family life, based on the equality of men and women and respecting
marriage and family rights—including the rights of the child—
should be offered to all adolescents. Programs on violence in the
home, particularly violence against women and child abuse, should
be provided through the educational system and the information

media. The implication here is that all actions aimed at eliminating direct and indirect discrimination against girls and women in educational systems also ensure that they achieve their full potential. These are the essential components of an education for peace, human rights, and democracy, and for the creation of a culture of peace.

UNESCO is currently organizing a high-level consultation (including an expert group meeting) on the contribution of women to a culture of peace in Beijing on 3 September 1995. The background paper for the expert group meeting poses a number of critical questions of which only three will be raised here:

First, what implications does the exclusion of women from the institutional power centers (which influence most cultural values and modes of thinking) have for the establishment of a culture of peace? Most power centers, such as political structures, tend to be largely male dominated, even when women have participated or have served as heads of state. For instance, the armed forces and organized religions are generally advocates of male superiority.

Second, the paper shows how *moral exclusion* nurtures other forms of exclusion. Moral exclusion is defined as the psychological process of rationalization of harmful or unfair treatment of others because they are deemed to be undeserving, inferior, or dangerous. Some examples of moral exclusion include the old justifications for apartheid and other forms of racism or political repression of dissidents. This discussion leads to another question: Is moral exclusion, practiced against half of the world's population, the greatest obstacle to a culture of peace?

Third, the paper also discusses the *hierarchical distribution of tasks and values* and proposes the partnership concept of shared power and responsibility as an alternative to the dependence-dominance ethos that now controls most cultures in the global system.

VALUES OF EDUCATION

In every educational approach and in every teaching group there are implicit values, because curricula are concerned with attitudes, values, and human relationships as well as with information, facts, and skills. Therefore, in order to produce curricula that address moral exclusion, we have to ask how much the educational system and society as a whole glorifies violence, power, and unquestioned

authority. We must identify which mechanisms in our societies and educational systems nurture these "values" as part of our collective search for peaceful conflict resolution, tolerance, equality, democracy, and the universal values of human rights. Perhaps if these values and attitudes were to lose their masculine or feminine connotations, discrimination based on gender would not exist. Would this then also be a major step toward a culture of peace in the world? Indeed, I believe it would.

—Director, Humanistic, Cultural, and
International Education, UNESCO

17

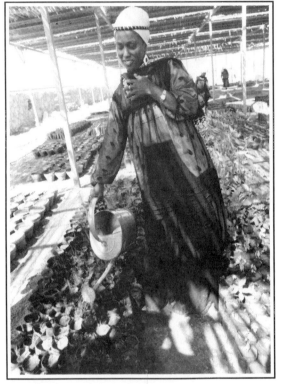

Nubian women running tree nurseries in upper Egypt.
INTERNAT'L LABOUR OFFICE/J. Maillard.

*W*OMEN, TECHNOLOGY,
AND THE ENVIRONMENT

Archalus Tcheknavorian-Asenbauer

The twentieth century has been characterized by, among other important social and political aspects, a heavy integration of women in productive employment as cheap labor. This fact has no direct relation to the plea of international organization's and women's groups for the emancipation of women. The fact remains, however, that female labor is required for certain low-paid manual jobs that men will not accept. In these cases, women have no job security, and if they get pregnant, their job may be given to a younger woman who is not pregnant nor has any children yet.

Statistics indicate that, of the more than two hundred million women employed in different industrial sectors, half are in developing countries. Although statistics do show an improvement in the status of women, a detailed analysis of the same data reveals that the majority of women are employed as unskilled workers. In the pharmaceutical sector, for example, women are dealing mainly with packaging activities and less with production, research, and development. They are even less visible in managerial positions. The same is true in the textile, electronics and other sectors where women's delicacy and intelligence could make a strong contribution to new developments. The twenty-first century could show a similar picture in which the need for women's participation in economic life will be higher and necessary to facilitate their contribution to the sustenance of the family.

International organizations concerned with the improvement of women's status should always consider two factors that interfere

with the effective participation of women in industry, namely, women's limited access to technology, and the application of inappropriate technologies in developing countries.

The acquisition of technologies that are often environmentally unsound is negotiated and even introduced by higher authorities. Developing countries' industrial development should not and cannot be based on dangerous and toxic technologies. Women's organizations, NGOs, and national authorities should together study carefully any new technology to be introduced in a given country. Under present circumstances, women who attempt to enter industrial production are often faced with inappropriate technologies that affect public health standards and therefore the health of their families.

When hazardous technological processes are applied, the ecological equilibrium in the immediate vicinity is destroyed: air is polluted and effluent discharged into the groundwater, contaminating it. More often than not, a few meters away from such factories, women collect water to cook, to wash their children, to drink, and so on. The quality of fruits, vegetables, and fish is endangered, sometimes rendering them poisonous.

The strong link between agricultural and industrial development should not be underestimated: the former produces basic raw materials but consumes industrial products (fertilizers, for example). As 60 to 70 percent of agricultural workers are women and children, they are often unaware of the characteristics of the products that they handle. Some chemical pesticides are carcinogenic, some are mixed with kerosene to be sprayed on crops, and others pose the risk of skin and lung cancer. Most users of pesticides and fertilizers in developing countries are completely unaware of these dangers.

UNIDO is currently trying to introduce biopesticides, that is, biologically degradable pesticides, in developing countries. Negotiations for technology transfer of these new industrially developed and patented biopesticides have been carried out. Research and development activities tor the production of similar products; based on locally available materials and using biotechnological processes, should also be promoted.

Governments should be made aware of the negative impact of wrongly selected and applied technologies on the present and future

generations. National regulatory bodies should prevent industrialists from introducing technologies that represent a risk to the ecosystem.

International organizations should focus on industrial education for women, both as housewives and entrepreneurs. Women entrepreneurs should know how to select the best technologies available on the market without jeopardizing the environment. This is decidedly more important in view of the global trend toward liberalization, which could influence the survival of small-and medium-scale businesses. Women entrepreneurs will require special support to improve the efficiency and effectiveness of their businesses. I would suggest the following:

- Easy-to-understand industrial and market information and opportunities should be made available to women entrepreneurs.

- Credit facilities for women entrepreneurs and supportive national policies are needed.

- Governments and manufacturers' associations should be encouraged to support investment in women's businesses.

- The creation of women entrepreneurs' associations should also be encouraged.

—*Managing Director, Industrial Sectors and Environment Division, UNIDO*

18

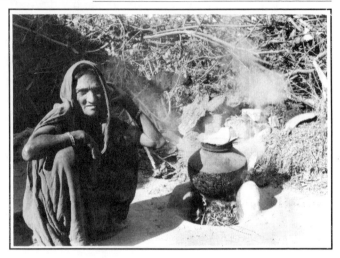

Indian Woman. WHO/A. Kochar

CLOSING REMARKS
Remie Touré

The Forum of Women was established some eight years ago. The advancement of women in the secretariat is our main concern. However, the forum has another basic objective that we have tried to achieve during the last two years, namely, to provide opportunities for networking within UNIDO, the United Nations system, and other bodies. What better occasion to bring women of the UN system together than the fiftieth anniversary of the United Nations.

This seminar, which has been organized with the full support of the UN organizations, has elaborated broad policy guidelines that could contribute to the development of a framework to advance certain issues related to the prospects and challenges of international development cooperation from a gender perspective and within the institutional framework of the UN system. In my view it is not an ambitious exercise. We have succeeded in bringing together women and men from the UN, NGOs, and the permanent missions to address issues which are normally left for the governments of member states.

On behalf of the Forum of Women Professionals, I would like to thank you all for your understanding and to ask for your forgiveness for our shortcomings. Some participants have suggested that this UN systemwide seminar should be repeated. I subscribe to that. We need not have the next meeting in Vienna, however. We could meet in Geneva, Rome, New York, Nairobi, or Paris sometime next year to follow up on the Beijing conference and to monitor progress being made on the issues that we have discussed.

It was a pleasure to have all of you here in Vienna. We have all benefited from this exercise, and I wish you all the best and a special bon voyage to our colleagues who have to travel back to their duty stations.

Thank you all.

—President, Forum of Women Professionals, UNIDO

Part IV

Recommendations

19

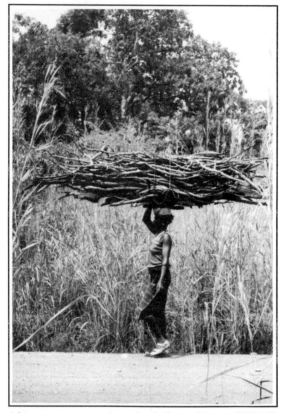

African woman carrying a load of wood home. WHO/E.
Mandelmann.

RECOMMENDATIONS FOR PRIORITY ACTION

The world, and the United Nations Organization, which represents it, appears to be at a crossroad. The survival of our physical world, our planet, is as much cause for concern as the survival of the United Nations as we know it. More than twenty years have been devoted by the United Nations to the advancement of the status of women. It is thus an opportune occasion to propose new horizons aimed at accelerating the elimination of the numerous obstacles which still impede the advancement of women, such as poverty, lack of educational opportunities, and deprivation of legal rights.

To overcome inequality one must consciously act to keep the issue of advancement of women in the fore. It is also essential to enlist more men.

We must accelerate the processes of change by formulating new policies for affirmative action as well as for a just society where dignity, freedom, and well-being are not only the benefit of the few but apply to all members of society.

We need to adopt a dynamic and holistic view in studying the relations between men and women, which for the most part have been determined by society. They are, consequently, subject to changes but such changes must be carefully monitored to ensure that they benefit women and men equally.

GENDER IN DEVELOPMENT: A CRITICAL ISSUE FOR SUSTAINABLE DEVELOPMENT

Gender should be seen through a balanced lens which takes into account the relationship between women and men. In so doing, one

has to take into consideration cultural variations of gender and adopt a comparative approach. In order to apply the concept of gender to "sustainable development," it requires an ongoing focus on substance and process which will promote human well-being and dignity, while protecting the environment.

The Seminar recommends that:

- Participation of women at the decision-making level should be increased to about 30 percent to ensure the qualitative difference, such as more human-centered values which women can bring to the decision-making process.

- Organizations of the United Nations system as well as NGOs should have gender-centered policies. All programs and projects should be evaluated to the extent to which gender development enhances equality and equity.

- The conditions under which women work should be evaluated considering that over two hundred million women are employed in industry all over the world.

- Women should be integrated into the totality of the programming exercise, and science and technology must be more gender sensitive and accessible to women.

WOMEN: AN INVALUABLE ASSET IN THE UNITED NATIONS FIELD OPERATIONS

The following actions are recommended:

- Urge the United Nations to encourage the assignment of women with experience in gender mainstreaming to senior-level field positions which should be seen as a positive investment, showing the multiplier effect in promoting the advancement of women.

- Involve local people in field operations by utilizing their own ideas in the development, improvement, and implementation of programs.

- Urge the United Nations system to take positive measures that will facilitate the assignment of women to senior level positions in the field and to create the supportive infrastructure and incentives.

- Special programming funds be set aside for field representatives to respond rapidly to specific innovative and catalytic activities relating to gender activities.

- Although the bottom-up approach is important to promote rural development, we need to strengthen the linkages and networks between rural and urban women to enhance their access to political influence.

THE IMPACT OF INFORMATION TECHNOLOGY ON WOMEN AS PARTNERS IN THE DEVELOPMENT PROCESS AND THE UNITED NATIONS SYSTEM

Fundamental microelectronics technologies underlying computing and communication technologies are changing very rapidly. Corresponding software and systems technologies needed to make effective use of available hardware are proceeding much more slowly. Nevertheless, information technology is forecast to be the largest industry in the world by the end of the century and is expected to account for 10 percent of the world GDP. Exciting new developments, which include the INTERNET, the information "Superhighway," are an interesting road that women can travel to an exciting destination. The potential is there, within the IT systems and information technology business, for women to grasp to advance to be full partners and hopefully leaders.

The Seminar recommends that women be encouraged to grasp these opportunities to develop creative roles in business and professions and, where necessary, do this in tandem with the sharing of their family responsibility.

- Women should use IT as an information and management tool and expand their expertise in the field in order to raise their perspective above the usual accepted secretarial/supporting role they usually hold.

- Ensure that women get the proper training in IT technologies and skills and that there is an equality of access in education for both boys and girls.

- Form partnerships between United Nations agencies, NGOs, and sponsors to provide the wherewithal in resources, both physical and human, to develop open programs of learning.

- Accentuate our efforts to bring women's issues to the fore—in this context the low pay, poor conditions, nonexistent career structure of women within the information technology manufacture process is particularly relevant—and work for achieving their rights and raising their standards to an acceptable higher standard.

- Every effort should be made to promote technical cooperation programs that give women in developing countries access to information technology and appropriate training.

IMPROVEMENT OF THE STATUS OF WOMEN IN THE UNITED NATIONS

The United Nations system has failed to adhere to Article 8 of the Charter. Recruitment and promotion of women in the United Nations has not been adequately implemented to achieve the objectives of the Charter. There are a number of existing policies which tend not to be executed.

The Seminar recommends the following:

- To make concerted efforts to implement existing policies fully as well as to develop new initiatives to increase the participation of women at all levels and especially at the senior level.

- To increase the presence of professional women in senior management positions, the United Nations common system should design executive development programs and ensure, to the extent possible, that 50 percent of those enrolled be women.

- To promote and intensify gender awareness issues in order to hold senior managers more accountable in the achievement of gender quality goals.

- To design career planning programs for junior professional women to ensure that they will have the opportunity to obtain the experience required to reach senior level management. This can be done through training and development programs.

- Senior management should be held more accountable for implementing or not implementing agreed resolutions.

- Career planning programs for Junior Professional Women should be instituted and implemented to ensure that they acquire the requisite capabilities to assume high positions in the future.

- A more accountable and responsive management procedure in the United Nations system focusing on human resources and development should be adopted.

- Comprehensive succession planning should be introduced.

- Women should be given more visible roles in the activities of the United Nations, selected to serve in the various task forces and represent their organizations at meetings and international fora. In particular, women in management positions should include an equal number of women on any task force and interagency meeting. Member states should also be encouraged to do the same.

- Interagency exchange training programs should be encouraged to improve gender sensitization in the United Nations system.

- Qualified and experienced women should be recruited to reflect women's experience and consensus in all aspects of the United Nations' work.

- Review personnel policies and guidelines to ensure conformity with the principles laid down in the Convention to Eliminate all Forms of Discrimination against Women and remove obstacles to the recruitment and retention of women staff.

WOMEN IN THE GLOBAL LABOR MARKET: EMPOWERMENT AND ENABLING ENVIRONMENT FOR PROGRESS

With globalization, technological information, economic reforms, liberalization, and demographic developments, there have been tremendous changes in the labor market with repercussions for women. They have created opportunities but also risks and challenges for women's employment. There have been positive developments in terms of a dramatic rise in most regions in women's levels of economic participation, but similar progress has not occurred in

terms of quality of employment and working conditions. Effective action toward the twenty-first Century to create an enabling environment for promoting equal opportunity and treatment for women in employment and to empower them requires:

The Seminar recommends:

- A comprehensive proactive, integrated strategy comprising a supportive legislative framework ratification and implementation of relevant international labor standards; reform and expansion of coverage of relevant national labor legislation to cover all categories of women, including those in the unorganized sectors; stricter enforcement of such laws; and legal literacy on women workers' rights.

- Gender-sensitive macro- and microeconomic and active labor market policies that take into account the gender-differential impact of such policies during their formulation and also permit monitoring gender impact during their implementation.

- Continuous training, skill diversification, and flexibility linked to emerging opportunities in the labor market and the changes in technology.

- Improvements in the quality of work in terms of pay and other working conditions and social security coverage.

- Affirmative action and other measures to promote women's increased representation and participation in decision making.

- Strengthening mobilization of different categories of women workers, such as in the trade unions and grassroots associations, to empower them.

- Generation of up-to-date gender-disaggregated statistics and documentation, and giving visibility to women's economic contribution to constitute appropriate bases for planning and monitoring impact of measures.

- Involvement of all the relevant actors, such as governments, the trade unions, and grassroots associations and nongovernmental organizations; cooperation and networking between these organizations in their efforts to promote and enhance women's participation quantitatively and qualitatively in the labor market.

- Recognizing that the central dilemma facing rural women is they are overemployed—in terms of hours worked—and underemployed—in terms of income received—efforts are needed to improve rural women's access to labor-saving technologies and to "break down" the household division of labor.

- ILO, UNESCO, and other bodies of the United Nations system can serve as a catalyst in terms of providing an international leadership role; serving as role models in their treatment of women within their systems; providing technical advisory services and technical cooperation assistance projects, especially to enhance vulnerable women workers' capacity; designing appropriate concepts and measurement instruments to assist in collecting gender-disaggregated statistics; disseminating information on women's education and workers' rights; and linking up with the relevant bodies and actors for concerted and effective action to have an impact.

- Provision of education and learning opportunities, a high priority in view of the empowerment of women, cannot be understated. This includes systematic measures to encourage women to obtain education in those fields traditionally occupied by men. Literacy and equal access to primary and secondary education are the first steps in this process.

- Teacher-training programs should be based on an analysis of educational processes in order to abolish sexist perceptions and stereotypes in curricula.

- As educational curricula are concerned with values, attitudes, and human relationships, it is important that education promotes values of tolerance, nonviolence, peaceful conflict resolution, equality of sexes, and universal values of human rights for everybody.

THE WOMAN ENTREPRENEUR: CHALLENGES IN AN AGE OF GLOBALIZATION OF ENTERPRISES

Women bring to business their patience, their sense of responsibility, and their multidirectional approach to their tasks. A woman's ability to handle diverse tasks at the same time is reinforced by her determination and attention to detail as well as her strong sense of responsibility.

The Seminar recommends the following:

- Resources should be coordinated in a concerted manner to empower women entrepreneurs.

- Action should be taken to break through the ring of power to reach people who really need assistance.

- Women in emerging economies should be given training in business systems, basic accounting, marketing, and computer and other skill development.

- Forces must be mobilized in a "global effort," and with a sense of urgency to launch a massive program of development projects at grassroots level, circumventing, wherever possible, time-consuming red tape procedures.

- The organizations of the UN system should use their resources in a coordinated and concerted manner.

- Women in developing and economies in transition should be empowered through skills training in new technologies.

- Information on production and consumption patterns should be provided to assist women entrepreneurs to identify new opportunities to improve on their products and services.

FINANCING WOMEN IN DEVELOPMENT PROGRAM: AN AGENDA FOR CHANGE

There is a need to refocus the macroeconomic policy dialogue on long-term development that stresses growth with equity with women taking their rightful place in the development equation.

The Seminar recommends the following:

- Incentives should be created for banks to amend their lending policies regarding collateral required of women. Lending policies could be based instead on a proven track record in repayment of informal loans.

- Legislation should be created that would require banks and other lending institutions to eliminate practices requiring a husband's consent or cosignature.

- Gender-sensitive incentives should be designed to ensure that the full potential of women's work is unleashed as an engine of growth.

- Support should be given to women's active participation in all institutions of governance and civil society, including financial management institutions.

- Major donors and bodies at the United Nations system should coordinate their efforts to ensure an integrated approach in funding women's programs.

- Closer cooperation should be established within the United Nations system for identifying, funding, and implementing women in development programs.

- It is proposed to set up a Forum at Beijing to discuss, on a cross-fertilization basis, the issue of financing women in development.

- Although the world is currently faced with donor fatigue, donors should be urged to make exceptions for women's programs.

- Financial resources should be allocated to gender mainstreaming in large projects, for instance, infrastructural projects.

WOMEN, TECHNOLOGY, HEALTH, AND THE ENVIRONMENT

Environmentally sound and sustainable development depends on the application of appropriate technology to ensure economic growth without damage to the people or to the environment.

Gender-sensitive approaches are required for an enabling environment that would promote sustainability. Through policies which stress equity, inclusion, and decentralization of decision making, the promotion of sustainable development which safeguards human heath can be assured.

The Earth Summit, in its *Agenda 21*, particularly Chapter 24 and Principle 20 of the Rio Declaration on Environment and Development, established women as protagonists in promoting sustainable development. The implementation of *Agenda 21* continues to face many obstacles, the most important of which are resource constraints, faulty development policies, and the low rate of participation of women in decision making.

Despite this fact, the sense of urgency evident for the Earth Summit and the Cairo Conference on Population and Development seems to be missing for Beijing.

The Seminar recommends the following:

- Action should be taken to promote awareness of the urgency and the interrelatedness of issues, especially their significance for women in both sectoral and cross-sectoral areas. Unless women are involved we will all suffer from global warming, etc.

- Alliances have to be built between women and men in a more consistent way to raise awareness about the direct effects of environmental degradation on everyone.

- Support women's important roles as guardians of environmental security and family health through international and national policies that will end environmental degradation and the unsound application of technology;

- Ensure women's participation at all levels and in all sectors of decision making by maintaining capacity-building measures that will ensure a steady supply of trained women in the environment, development science, and technological fields.

*Selected Recent Resolutions
of the Commission on
the Status of Women*

RESOLUTION A

MONITORING THE IMPLEMENTATION OF THE NAIROBI FORWARD-LOOKING STRATEGIES FOR THE ADVANCEMENT OF WOMEN

Antigua and Barbuda, Argentina,* Bangladesh,* Bolivia,* Cote d'Ivoire,* Gambia,* Indonesia,* Pakistan, Philippines, Republic of Korea and Switzerland:* draft resolution*

Traffic in Women and Girls

The Commission on the Status of Women,

Reaffirming its faith in fundamental human rights, in the dignity and worth of the human person and in the equal rights of men and women, enshrined in the Charter of the United Nations,

Reaffirming the principles set forth in the Universal Declaration of Human Rights,[1] the Convention on the Elimination of All Forms of Discrimination against Women,[2] the International Covenants on Human Rights,[3] the Convention against Torture and Other Cruel, Inhuman or Degrading Treatment or Punishment,[4] the Convention on the Rights of the Child,[5] and the Declaration on the Elimination of Violence against Women,[6]

*In accordance with rule 69 of the rules of procedure of the functional commissions of the Economic and Social Council.

Recalling that the Vienna Declaration and Programme of Action[7] affirmed the human rights of women and girl children as an inalienable, integral and indivisible part of universal human rights,

Welcoming the recognition by the World Summit for Social Development of the danger to society of the trafficking in women and children,

Convinced of the need to eliminate all forms of sexual violence and trafficking in women and girls which are violations of the human rights of women and girl children,

Condemning the illicit and clandestine movement of persons across national and international borders, largely from developing countries and some countries with economies in transition, with the end goal of forcing women and girl children into sexually or economically oppressive and exploitive situations, for the profit of recruiters, traffickers and crime syndicates, as well as other illegal activities related to trafficking, such as forced domestic labour, false marriages, child marriages, clandestine employment and false adoption,

Noting the increasing number of women and girl children from developing countries and from some countries with economies in transition who are being victimized by traffickers, and acknowledging that the problem of trafficking also victimizes young boys,

Recalling that the Commission on Human Rights, in its resolution 1994/45 of 4 March 1994, called for the elimination of trafficking in women,

Aware of the decision of the commission on Crime Prevention and Criminal Justice in its resolution 3/2 of 6 May 1994 to consider the international traffic in minors at its fourth session in the context of its discussions on the question of organized transitional crime,

Realizing the urgent need for the adoption of effective measures at the national, regional, and international levels to protect women and girl children from this nefarious traffic,

1. *Expresses its grave concern* over the worsening problems of trafficking, particularly the increasing syndication of the sex trade and the internationalization of the traffic in women and girl children;

2. *Welcomes* the Programme of Action of the International Conference on Population and Development[8] held at Cairo from 5 to 13 September 1994, which, *inter alia*, called upon all Governments to prevent all international trafficking in migrants, especially for

the purpose of prostitution, and for the adoption by Governments of both receiving countries and countries of origin of effective sanctions against those who organize undocumented migration, exploit undocumented migrants or engage in trafficking in undocumented migrants, especially those who engage in any form of international traffic of women and girl children;

3. *Invites* Governments to combat trafficking in women and children through nationally and internationally coordinated measures, at the same time establishing or strengthening institutions for the reabilitation of the victims of trafficking of women and children, and to ensure for victims the necessary assistance, including legal support services that are linguistically and culturally accessible, towards their full protection, treatment and rehabilitation;

4. *Invites* Governments to consider the development of standard minimum rules for the humanitarian treatment of trafficked persons, consistent with internationally recognized human rights standards;

5. *Encourages* Governments, relevant oreganizations and bodies of the United Nations system, intergovernmental organizations and non-governmental organizatons to gather and share information relative to all aspects of trafficking in women and girl children in order to facilitate the development of anti-trafficking measures, and to adopt appropriate measures to create wider public awareness of this problem;

6. *Calls upon* all Governments to take appropriate measures to prevent the misuse and exploitation by traffickers of such economic activities as the development of tourism and the export of labour;

7. *Encourages* Member States to sign, ratify and accede to the Convention for the Suppression of the Traffic in Persons and the Exploitation of the Prostitution of Others,[9] international agreements on the suppression of slavery and all other relevant international instruments;

8. *Draws* the attention of the Special Rapporteur on Violence against Women and the Working Group on Contemporary Forms of

Slavery of the Subcommission on Prevention of Discrimination and Protection of Minorities to the problem of trafficking in women and girl children;

9. *Welcomes* the adoption by the subcommission of its resolution 1994/5 recommending that Governments adopt legislation to prevent child prostitution and child pornography;

10. *Also draws attention* to the report of the Special Rapporteur on the sale of Children, Child Prostitution and Child Pornography;

11. *Invites* the Fourth World Conference on Women and the Ninth United Nations Congress on the Prevention of Crime and the Treatment of Offenders to consider including in their respective programmes of action the subject of the traffic in women and girl children;

12. *Recommends* that the problem of trafficking in women and girl children be given consideration within the implementation of all relevant international legal instruments and, if need be, that consideration be given to measures to strengthen them, without undermining their legal authority and integrity;

13. *Requests* the Economic and Social Council at its substantive session of 1995 to submit a report to the Secretary-General for inclusion in a preliminary report to the General Assembly at its fiftieth session on the implementation of the present resolution under the item entitled "Advancement of Women";

14. *Requests* the Secretary-General to focus the International Day for the Abolition of Slavery, 2 December 1996, in the problem of trafficking in human persons, especially women and children, and to devote one session of the fifty-first session of the General Assembly to the discussion of this problem.

NOTES

This resolution was drafted at the thirty-ninth session of the Commission the Status of Women, New York, 15 March–4 April 1995.

1. Resolution 217 A (III).

2. Resolution 34/180, annex.

3. Resolution 2200 A (XXI).

4. Resolution 39/46, annex.

5. Resolution 44/25, annex.

6. Resolution 48/104, annex.

7. *Report of the World Conference on Human Rights, Vienna, 14–25 June 1993* (A/Conf.157/24 (Part I)), chap III.

8. A/CONF.171/13, chap. I.

9. Resolution 317 (IV), annex.

RESOLUTION B

MONITORING THE IMPLEMENTATION OF THE NAIROBI FORWARD-LOOKING STRATEGIES FOR THE ADVANCEMENT OF WOMEN

Azerbaijan: draft resolution*

Relief to Women and Children Who Have Been Taken As Hostages and Imprisoned in Armed Conflicts, to be Provided by the Beginning of the Fourth World Conference on Women

The Commission on the Status of Women,

Taking into consideration the fact that the main objective of the Fourth World Conference on Women: Action for Equality, Development and Peace, to be held in Beijing, China, from 4 to 15 September 1995, is to promote the achievement of equality, development and peace,

Expressing grave concern that the number of armed conflicts has not decreased since the end of the cold war, and that international and ethnic conflicts are an ongoing reality in nearly every region, resulting in violations of human rights, especially those of women and children, including massive loss of life,

Noting with alarm that the humanitarian law prohibiting attacks on civilian populations is systematically ignored,

Confirming that the taking of women and children as hostages, and their imprisonment and subjection to torture and violence are in grave contravention of human morality and all international legal norms,

Expressing its strong belief that the rapid and unconditional release of women and children by parties to conflicts will contribute greatly to achieving the above-mentioned goals of the Beijing Conference,

*In accordance with rule 69 of the rules of procedure of the functional commissions of the Economic and Social Council.

Noting that the implementation of this initiative would serve as strong confirmation of the effectiveness of the Conference's goal of action for equality, development and peace,

1. *Strongly appeals* to all parties concerned to strictly observe and respect the rules of international humanitarian law, as set out in the Geneva Conventions of 12 August 1949[1] and the Additional Protocols thereto, of 1977;[2]

2. *Appeals* to the parties to conflicts to strive for a peaceful, negotiated settlement of their differences;

3. *Urges* all parties to conflicts to release all women and children who have been taken as hostages and imprisoned in areas of armed conflict, before the opening of the Fourth World Conference on Women, to be held in Beijing, China, from 4 to 15 September 1995, and thereby carry out an action for peace and justice;

4. *Requests* the Secretary-General to use all appropriate measures to ensure that women and children who have been imprisoned as hostages in zones of armed conflict are released by the beginning of the Beijing Conference;

5. *Also requests* the Secretary-General to report to the Fourth World Conference on Women on the progress made in the implementation of the present resolution, as well as to submit a report to the commission on the Status of Women at its fortieth session, on the implementation of the present resolution.

NOTES

This resolution was drafted at the thirty-ninth session of the Commission on the Status of Women, New York, 15 March–4 April 1995.

1. United Nations, Treaty Series, vol. 75, Nos. 970-973.

2. Ibid., vol. 1125, Nos. 17512 and 17513.

RESOLUTION C

PROGRAMMING AND COORDINATION MATTERS RELATED TO THE UNITED NATIONS AND THE UNITED NATIONS SYSTEM

Armenia, Australia, Austria, Bahamas, Belarus, Bosnia and Herzegovina,* Cambodia,* Canada,* Colombia, Cote d'Ivoire, Cyprus, Czech Republic,* Denmark,* El Salvador,* Finland, Iceland,* Japan, Kenya, Liberia,* Liechtenstein,* Marshall Islands,* Micronesia (Federated States of),* Netherlands,* New Zealand,* Nigeria,* Norway,* Pakistan, Papua New Guinea,* Portugal, Republic of Korea, Samoa,* Slovenia,* Solomon Islands,* Spain, Suriname,* Sweden,* Thailand, Turkey,* United States of America* and Venezuela: draft resolution*

Improvement of the Status of Women in the Secretariat

The commission on the Status of Women recommends to the Economic and Social Council the adoption of the following draft resolution:

The Economic and Social Council,

Recalling Articles 1 and 101 of the Charter of the United Nations,

Recalling also Article 8 of the Charter, which provides that the United Nations shall place no restrictions on the eligibility of men and women to participate in any capacity and under conditions of equality in its principal and subsidiary organs,

Recalling further the relevant paragraphs of the Nairobi Forward-looking Strategies for the Advancement of Women,[1] especially paragraphs 79, 315, 356 and 358,

Recalling further the relevant resolutions and decisions of the General Assembly, the Economic and Social Council and other bodies that have continued to focus on this area since the adoption of

*In accordance with rule 69 of the rules of procedure of the functional commissions of the Economic and Social Council.

Assembly resolution 2715 (XXV) of 15 December 1970, in which the question of the employment of women in the Professional category was first addressed,

Concerned at the serious and continuing underrepresentation of women in the Secretariat, particularly at the higher decision-making levels,

Convinced that the improvement of the status of women in the Secretariat could significantly enhance the effectiveness and credibility of the United Nations, including its leadership role in advancing the status of women world wide and in promoting the full participation of women in all aspects of decision-making,

Recalling the goal, set in General Assembly resolutions 45/125 of 14 December 1990 and 45/239C of 21 December 1990 and reaffirmed in Assembly resolutions 46/100 of 16 December 1991, 47/93 of 16 December 1992, 48/106 of 20 December 1993 and 49/167 of 23 December 1994, of a 35 per cent overall participation rate of women in posts subject to geographical distribution by 1995,

Noting with concern that the current rate of increase in the appointment of women may not be sufficient to achieve the objective of a 35 per cent participation rate of women in posts subject to geographical distribution by 1995,

Recalling the goal, set in general assembly resolution 45/239 C and reaffirmed in Assembly resolutions 46/100, 47/106 and 49/167, of a 25 per cent participation rate of women in posts at the D-1 level and above by 1995,

Noting with disappointment that the participation rate of women in posts at the D-1 level and above remains unacceptably low, and well below the 25 per cent goal,

Noting the efforts made in the past year by the Secretary-General and the Office of Human Resources Management of the Secretariat to integrate the objectives set by the General Assembly for the improvement of the status of women in the Secretariat into the overall strategy for the management of the Organization's human resources, and noting also that such a comprehensive approach will be conducive to enhancing the status of women in the Secretariat,

Recognizing the importance of providing equal employment opportunities for all staff,

Aware that a comprehensive policy aimed at preventing sexual harassment should be an integral part of personnel policy,

Commending the Secretary-General for his administrative instruction on procedures for dealing with cases of sexual harassment,

Bearing in mind that a visible commitment by the Secretary-General is essential to the achievement of the targets set by the General Assembly,

1. *Takes note* of the report of the Secretary-General on the improvement of the status of women in the Secretariat[2] while regretting the lateness in the availability of the report;

2. *Also takes note* of the strategic plan of action for the improvement of the status of women in the Secretariat (1995–2000),[3] as contained in the above-mentioned report of the Secretary-General, and of the goals and objectives of the strategic plan as proposed by the Secretary-General;

3. *Urges* the Secretary-General to implement fully the strategic plan of action for the improvement of the status of women in the Secretariat (1995–2000), noting that his visible commitment is essential to the achievement of the targets set by the General Assembly and the goals and objectives contained in the strategic plan;

4. *Welcomes* the intention of the Secretary-General to ensure implementation of the strategic plan through, *inter alia*, the issuance of clear and specific instructions as to the authority and responsibility of all managers in implementing the plan and the criteria by which performance will be appraised;

5. *Urges* the Secretary-General, in accordance with the charter of the United Nations and in such a way as is consistent with the strategic plan, to accord greater priority to the recruitment and promotion of women in posts subject to geographical distribution, particularly in senior policy-level and decision-making posts and within those parts of the United Nations system and the specialized agencies where representation of women is considerably below the average, in order to achieve the goals set in General Assembly resolutions 45/125 and 45/239 C of an overall participation rate of 35 per cent by 1995 and in posts at the D-1 level and above of 25 per cent by 1995;

6. *Also urges* the Secretary-General to examine further existing work practices within the United Nations system with a view to

increasing flexibility so as to remove direct or indirect discrimination against staff members with family responsibilities, including consideration of such issues as spouse employment, job sharing, flexible working hours, child-care arrangements, career-break schemes and access to training;

7. *Further urges* the Secretary-General to increase the number of women employed in the Secretariat from developing countries, particularly those that are unrepresented or underrepresented, and from other countries that have a low representation of women, including countries in transition;

8. *Requests* the Secretary-General to ensure that equal employment opportunities exist for all staff;

9. *Also requests* the Secretary-General to enable, from within existing resources, the Focal Point on the Status of Women within the Secretariat to effectively monitor and facilitate progress in the implementation of the strategic plan;

10. *Strongly encourages* Member States to support the strategic plan and the efforts of the United Nations and the specialized agencies to increase the percentage fo women in the Professional category, especially in posts at the D-1 level and above, by identifying and sending forward more women candidates, encouraging women to apply for vacant posts and creating national rosters of women candidates to be shared with the Secretariat, the specialized agencies and the regional commissions;

11. *Requests* the Secretary-General to further develop comprehensive policy measures aimed at the prevention of sexual harassment in the Secretariat;

12. *Also requests* the Secretary-General to ensure that a progress report on the status of women in the Secretariat containing, *inter alia*, information on activities undertaken towards the achievement of the goals and objectives contained in the strategic plan and policy measures aimed at the prevention of sexual harassment in the Secretariat is presented to the Commission on the Status of Women at its fortieth session, in accordance with the relevant rules concerning the timetable for delivery of documentation, and to the General Assembly at its fiftieth session.

Notes

This resolution was drafted at the thirty-ninth session of the Commission on the Status of Women, New York, 15 March–4 April 1995.

1. *Report of the World Conference to Review and Appraise the Achievements of the United Nations Decade for Women: Equality, Development and Peace, Nairobi, 15–26 July 1985* (United Nations publication, Sales No. E.85/IV.10), chap. I, sect. A.

2. A/49/587 and Corr.1.

3. Ibid., sect. IV.

LIST OF ACRONYMS

ACC—Administrative Committee on Coordination

COMFAR—UNIDO Computer Module for Feasibility Analysis and Reporting

CSW—Commission on the Status of Women

ECLAC—Economic Commission for Latin America and the Caribbean

ECOSOC—Economic and Social Council

EC—European Community

FAO—Food and Agriculture Organization

GID—Gender in Development

HANOMI—Taken from three words in Spanish, *Hagalo nosotras mismas*, which means "let's do it ourselves." HANOMI represents a series of projects set up aroud Argentina in poor villages to create jobs and small enterprises for women, mainly through small cooperatives to generate income and help these small communities by including, where possible, other famililes as well.

IFAD—International Fund for Agricultural Development

IFBPW—International Federation of Business and Professional Women

ILO: International Labour Office

INSTRAW—International Research and Training Institute for the Advancement of Women

IT—Information technology

IUCN—International Union for the Conservation of Nature and Natural Resources

JAC—Joint Advisory Committee

JIU—Joint Inspection Unit

NFLS—Nairobi Forward-Looking Strategies

NGO—Nongovernmental Organization

OECD—Organization for Economic Cooperation and Development

OHRM—Office of Human Resources Management

OXFAM—Oxford Committee for Famine Relief

PAC—Primary Environmental Care

PRODEC—Programme for Development Cooperation

SEGA—Socio-Economic and Gender Analysis

SEWA—Self-Employed Women's Association

SME—Small and Medium Enterprises

UN—United Nations

UNCED—United Nations Conference on Environment and Development

UNDP—United Nations Development Programme

UNESCO—United Nations Educational, Social, and Cultural Organizations

UNIDO—United Nations Industrial Development Organization

UNRISD—United Nations Research Institute for Social Development

UNIFEM—United Nations Development Fund for Women

WIDE—Women in Development, Europe

WID—Women in Development

WWB—Women's World Banking

Other Presenters

Elisabetta Belloni—First Secretary, Permanent Mission, Italy

B. Chambalu—Consultant, WID

James Dargie—Director, FAO/IAEA Joint Division, IAEA

Christine Dodeson—Director, UN Office in Vienna

Carla Fjeld—IAEA

Irene Freudenschuss-Reichl—Alternate Permanent Representative, Austria

Vera Gregor—UNIDO

Olubanké Y. King-Akérélé—UNIDO

Honorine Kiplagat—UNEP

Judith Lavnick—UNIDO

Marie-Anne Martin—UNIDO

Mickela Moore—Coordinator, WCN

Fugen Ok—Permanent Representative, Turkey

Jeannine Orlowski—UNIDO

Leonardo Pineda-Serna—UNIDO

Vibeke Rovsing-Jorgensen—Alternate Permanent Representative, Denmark

Kemal Saiki—UNIDO

Geoffrey Toothy—Adviser to the Permanent Representative, Australia

Notes on Contributors

Camillo Antonio, a Filipino national, has a background in political science and international relations as well as marketing and management. He was awarded a doctoral fellowship in development studies at Georgetown University in the United States. Antonio has promoted entrepreneurship development for over twenty-five years and is a specialist in human resource development. He joined UNIDO in 1977 as industrial development officer and has worked in several developing countries promoting entrepreneurship development. He is currently acting head of Human resource development at UNIDO.

Enid Burke (née de Silva) has worked for eighteen years in the United Nations system, eight of them with UNIDO. Currently working in the External Relations department of UNIDO, she was previously, over a period of twelve years, a librarian, schoolteacher, feature newswriter, TV and radio scriptwriter and presenter, government information officer, press officer, magazine editor, public relations consultant, lecturer in mass communications, and university research fellow. Among her most memorable assignments have been exclusive radio and newspaper interviews with the first president of Kenya, Jomo Kenyatta; President Banda of Malawi; former U.S. attorney-general Robert Kennedy; and actor Sidney Poitier.

Eugenia Date-Bah is a sociologist educated at the University of Ghana and the London School of Economics. She holds a Ph.D. from the University of Birmingham, England. She was a university lecturer for several years in her native Ghana before joining the ILO fifteen years ago. Her recent assignments include being the manager of the ILO multidisciplinary research and promotional initiative called the Interdepartmental Project on Equality for Women in Employment, and also senior technical specialist on women workers

and gender questions. She has a number of publications on women's issues and occupational sociology.

Konrad Fialkowski is a senior industrial development officer in the Technology Development Section of UNIDO. His field of work concentrates on information technology in developing countries, particularly with regard to increased awareness, strengthened national capabilities, regional cooperation, information technology, promotion of technology transfer, and strengthening or promotion of test facilities. The program also provides guidelines for the purchase and use of hardware and software, as well as strengthening developing countries' capabilities through information technology application centers or core groups. Special emphasis is now given to computer applications in small- and medium-scale industry. Fialkowki joined UNIDO in 1982.

Anne Forrester, a national of the United States of America, is deputy director of the UNDP's Regional Bureau for Africa. She holds a B.A. in anthropology and history from Bennington College, USA; an M.A. in African studies from Howard University, USA; a Ph.D. in international studies from Union Graduate School, USA. Forrester has served in the United Nations system as deputy resident representative, UNDP Lesotho (1985–86); resident representative, UNDP Ghana (1986–90); special assignment as principal officer, Division of Personnel and Regional Bureau for Africa (RBA), UNDP New York (1990–91); chief, Division T, RBA, UNDP New York (1991–94). Prior to U.N. Service she worked for the US government as staff director, Subcommittee on Africa, Foreign Affairs Committee, US House of Representatives (1982–85); ambassador to the Republic of Mali (1979–81); director, Office of US Ambassador to the UN (1977–79); and legislative assistant for foreign affairs, US House of Representatives (1975–77). Her academic positions have included the following: adjunct professor, African Studies Department, Georgetown University (1983–85); executive director, Black Student Fund (1972–75); lecturer/assistant professor in African studies, Howard University and SUNY Buffalo (1969–71).

Leena M. Kirjavainen, a national of Finland; is currently the director of the Division of Women and People's Participations in Development, Sustainable Development Department, FAO, Rome, Italy. She is a household economist, with specializations in resources manage-

ment and time use studies. Kirjavainen holds degrees in household economics and resource management, both from Virginia Tech (USA, 1984) and the University of Helsinki (Finland, 1989), and an MPA degree in public administration from the Kennedy School of Government, Harvard University (USA, 1991).

Tamara Martinez is director of the International Federation of Professional Women, having served the organization in various capacities over a number of years. She has also been a translator, tutor, and consultant, with interests in literature, art, music, theater, and current affairs.

Chafika Meslem, a native of Algeria, joined the United Nations in Vienna in 1981 as director of the Division for the Advancement of Women of the Center for Social Development and Humanitarian Affairs, where she served until 1993. During this period, she became deputy secretary-general of the Nairobi World Conference for Women. She joined UNCTAD in 1993 and now heads the Division of Economic Cooperation among Developing Countries and Special Programs, which includes the Poverty Alleviation Program, the work in UNCTAD on the New Agenda for Africa, and the Special Economic Unit for Palestine. From 1977 to 1981 she was deputy permanent representative of her country to the United Nations office in Geneva.

Adot Oleche received her training in development studies with a focus on women's issues, particularly women and fertility. A national of Kenya, she has worked in the UN system for ten years as a UNDP national program officer for Kenya. She is currently an industrial development officer with the Industrial Sector and Environment Division of UNIDO.

Sylvia Perry has been the regional coordinator for Europe (twenty-six countries within and outside the EU) for the International Federation of Business and Professional Women since July 1993. Previously she has been chairperson of the Public Relations Standing Committee, workshops organizer at both international and European congresses, and national president of BPW UK Ltd. (1989–91). she has also served as vice chair of the Board of School Governors, chair of a charity trust for disabled people, and fellow of the Royal Society of Arts. Formerly a senior manager with Royal Mail, controlling major

buildings projects, she is now director of Perbane Associates Ltd., engaged in marketing electronic products.

Kaisa Savolainen, director on the Sector of Education, UNESCO (Paris), since October 1986, was born in Finland. She received an M.A. from the University of Jyvaskyla, Finland, in 1964 (psychology, special education, pedagogy, sociology). She had worked as a psychologist and a teacher and was chief inspector, National Board of General Education of Finland from 1973 to 1979. She has also held positions and memberships in several committees and advisory boards in the fields of education in Finland and for the Nordic countries. The author of numerous articles and radio programs, she has been a member of the Council of Senior Advisors of the International Association of University Presidents since 1992.

Filomina Chioma Steady is special advisor to UNIDO on the integration of women in sustainable development for the Beijing conference. She was special advisor on women to Maurice Strong, secretary-general of the 1992 Earth Summit, and a former director of the United Nations Branch for the Advancement of Women. She has also served on delegations to several UN and other international meetings. A national of Sierra Leone, she received her B.A. in government from Smith College, M.A. in anthropology from Boston University, and Ph.D. in social anthropology from Oxford University. Formerly a professor at several universities in the United States and a lecturer at the University of Sierra Leone, she has published extensively on the subject of women, the environment, and sustainable development.

Archalus Tcheknavorian-Asenbauer is managing director of the industrial sectors and environment division of UNIDO. She joined UNIDO in 1970 as industrial development officer and was appointed chief of the pharmaceutical unit in 1979. A chemical engineer by training, she studied at the Technical University in Vienna. From 1962 to 1966 she was associate professor at the national university of Iran, her native country. Having served as head of several delegations and numerous task forces, she is the chairperson of the interdivisional task force of UNIDO for the preparations for the Beijing conference. As founder of the Forum of Women Professionals she continues to serve in the forum as an honorary president.

Remie Touré is currently a senior area program officer in the Africa Program of the Country Strategy and Program Division of UNIDO, with resposibility for the Regional Africa Program and Policy Issues. On completion of her postgraduate degree in economics, she served from 1971 to 1974 as an economist in the office of the economic advisor of the president of Sierra Leone, her native country. Later, as acting deputy development secretary of the Ministry of Development and Economics Planning, she led delegations and participated in several intergovernmental conferences and meetings. In 1980 she joined the United Nations as an economic affairs officer with the Economic Commission for Africa in Addis Ababa. Active in promoting the advancement of women at the national, regional, and international levels, she is currently the president of the Forum of Women Professionals in UNIDO.

Reginald van Raalte was born in the Netherlands. After primary and secondary education in France and Switzerland, he graduated from Dartmouth College with a B.A. in Economics (1957) and from Harvard Law School (LL.B. 1960). He practiced law in New York City for six years before joining the US Foreign Service in 1966, serving the US Agency for International Development successively in Ecuador, Brazil, Indonesia, Ivory Coast, Egypt, and Bolivia. In 1990–93, he worked with the USAID environmental coordinator to develop an agencywide environmental strategy, and as program director for AID's Bureau for Private Enterprise. After working as a consultant in international development in 1993, he joined UNIDO in April 1994 as managing director for administration.

Rosina Wiltshire has a Ph.D. in political science and was coordinator for the Environment and Development Program of DAWN (Development Alternatives with Women in a New Era). She has taught at universities in the Caribbean and in Canada and has worked as coordinator of women's studies and development programs. She recently held a position with the International Development Research Council (IDRC) of Canada and is currently the manager of the Gender in Development program at UNDP.